THE UNIVERSITY OF MICHIGAN
CENTER FOR CHINESE STUDIES

MICHIGAN PAPERS IN CHINESE STUDIES
NO. 39

MAO ZEDONG'S "TALKS AT THE
YAN'AN CONFERENCE ON LITERATURE AND ART":
A TRANSLATION OF THE 1943 TEXT WITH COMMENTARY

by
Bonnie S. McDougall

Ann Arbor

Center for Chinese Studies
The University of Michigan

1980

Library of Congress Cataloging in Publication Data

McDougall, Bonnie S., 1941–
 Mao Zedong's "Talks at the Yan'an conference on
literature and art."

 (Michigan papers in Chinese studies; no. 39)
 1. Mao, Tse-tung. Tsai Yen-an wen i tso t'an
hui shang ti chiang hua. 2. Arts--China--Addresses,
essays, lectures. I. Mao, Tse-tung, 1893-1976.
Tsai Yen-an wen i tso t'an hui shang ti chiang hua.
English. II. Title. III. Series.

NX583.A1 M3634 700'.951 80-18443
ISBN 0-89264-039-1

Printed in the United States of America

In memoriam

Ruth Constance McDougall

CONTENTS

Note on Romanization

 Pinyin romanization has been used throughout, except for some common geographical names such as Peking. For readers more familiar with Wade-Giles romanization, I append a list of the two or three versions of the names of major characters mentioned below.

Pinyin	*Wade-Giles*	*Peking Review**
Mao Zedong	Mao Tse-tung	Mao Tsetung
Lu Xun	Lu Hsün	Lu Hsun
Zhou Yang	Chou Yang	
Qu Qiubai	Ch'ü Ch'iu-pai	Chu Chiu-pai
Guo Moruo	Kuo Mo-jo	
Ding Ling	Ting Ling	
Wang Shiwei	Wang Shih-wei	
Jiang Qing	Chiang Ch'ing	Chiang Ching
Ai Qing	Ai Ch'ing	Ai Ching

* A modified form of Wade-Giles, used for names of well-known peo-
ple in English-language Chinese publications.

ACKNOWLEDGMENTS

This work was conceived and carried out at the John K.
Fairbank Center for East Asian Research at Harvard University.
I am most grateful to Ezra F. Vogel, then director of the Center,
for making it possible for me to come to the Center as a Research
Fellow in 1976 and for his continued support and encouragement
thereafter. I am also very grateful to Roy M. Hofheinz, Jr.,
current director of the Center, for extending my tenure as a
Research Fellow in 1977 and 1978 and for his help and goodwill.
I owe a great deal to the other members of the Center, especially
to the lunch room regulars on whom many of my ideas were first
tested and who generously gave forth of their own. In particular
I should like to thank Benjamin I. Schwartz and John E. Schrecker
for reading the manuscript and for their valuable suggestions.
I should also like to thank John K. Fairbank for his interest and
encouragement. A preliminary version of my commentary on the
"Talks" was read to the Harvard East Asian Literature Colloquium
in November 1976, and I am most grateful to its members for their
suggestions and interest. Throughout the work on this project
I have received the greatest encouragement and assistance from
Michael Wilding, and I am particularly grateful for his guidance in
the world of Western literary criticism. I wish to thank Harriet C.
Mills for her encouragement and advice on the publication of the
manuscript. I am also very grateful to Barbara Congelosi for her
painstaking editorial work. Finally, I should like to thank Anders
Hansson for his suggestions and corrections from the time when this
project first took shape to its present publication.

B. McD.
June 1980

I have known many poets. Only one
was as he should be, or as I should
wish him to be. The rest were stupid
or dull, shiftless cowards in matters
of the mind. Their vanity, their
childishness, and their huge and
disgusting reluctance to see clearly.
Their superstitions, their self-importance,
their terrible likeness to everyone else
as soon as their work was done, their
servile minds. All this has nothing to
do with what is called literary talent,
which exists in perfect accord with
downright stupidity.

Paul Valéry, *Cahiers*, 1:193[1]

Mutual disdain among men of letters
goes back to ancient times.

Cao Pei (186-226)

INTRODUCTION

The Yan'an "Talks" as Literary Theory

The writings of Mao Zedong have been circulated throughout the world more widely, perhaps, than those of any other single person this century. The "Talks at the Yan'an Conference on Literature and Art" has occupied a prominent position among his many works and has been the subject of intense scrutiny both within and outside China. Yet, despite its undoubted importance to modern Chinese literature and history, the "Talks" has never been thoroughly examined with regard to various elements of literary theory therein contained, i.e., with regard to Mao's views on such questions as the relationship between writers or works of literature and their audience, or the nature and value of different kinds of literary products. While it can hardly be argued that a cohesive and comprehensive "theory" emerges in the course of Mao's "Talks," the purpose of this study is to draw attention to those of Mao's comments whose significance is primarily literary, as distinguished from political or historical.

In light of modern Western literary analysis, Mao was in fact ahead of many of his critics in the West and his Chinese contemporaries in his discussion of literary issues. Unlike the majority of modern Chinese writers deeply influenced by Western theories of literature and society (including Marxism), Mao remained close to traditional patterns of thought and avoided the often mechanical or narrowly literal interpretations that were the hallmark of Western schools current in China in the early twentieth century. For example, Western-influenced critics and writers unconsciously assumed elite status and addressed an elite or potentially elite audience, implicitly accepting a division between high or elite audiences and low or popular audiences for literature; on the other hand, Mao seemed to take for granted a relative harmony between traditional Chinese elite and popular culture, such as may also have existed in the Western past but which had disappeared in the modern era. Moreover, Mao appears not to have been troubled by typical Marxist difficulties regarding "mind" and "matter"; like Marx

3

himself, he did not feel constrained to establish a consistent material basis for every phenomenon in the nonmaterial superstructure. Finally, unlike most modern Chinese writers, who operated on the basis of a clearly defined (and therefore limited) school, Mao followed traditional practice in his own poetry, for which no explicit theoretical justification was required. As Matthew Arnold noted in a different context, being in touch with the mainstream of national life releases one from the need for continual self-assertion that obsesses the dissident. It may be argued that following traditional literary practice in his poetry left Mao free to form literary judgments on an instinctual and nondogmatic level, whereas the Westernized writers were obliged to rationalize their practice from given, specific theoretical premises. The freedom to draw with ease on his own experience and not restrict himself to any currently available model of Western literary theory or practice could also explain the combination of ontological simplicity in his general thinking on literature and keen insights into specific questions.

Detailed discussions on the "Talks" first appeared in the West in the fifties and sixties, notably in such works as C. T. Hsia's *History of Modern Chinese Fiction* (1961), the special edition of *China Quarterly* on communist Chinese literature (1963),[2] especially in the articles by Cyril Birch, Howard F. Boorman, and T. A. Hsia, Douwe Fokkema's *Literary Doctrine in China and Soviet Influence* (1965), and Merle Goldman's *Literary Dissent in Communist China* (1967). However, these discussions are almost solely concerned with the political significance and effects of Mao's "Talks." With some exceptions, they are also mostly concerned with the fate of Westernized writing and writers in China. Insofar as there are comments on the literary significance of the "Talks," they are largely disparaging, such as Fokkema's "[the 'Talks'] deal only superficially with problems of literary form and are concentrated mainly on political and moral questions."[3] From T. A. Hsia comes a grudgingly favorable "one doesn't have to quarrel so much with Mao's theory as with the fact of control."[4] One reason for Hsia's relatively mild attitude is perhaps that he alone of the writers listed above referred to the original version of the "Talks," in which Mao's literary theories are spelled out in more detail. I have no wish here to dispute the findings of these writers in regard to the political significance and effects of Mao's "Talks," and I endorse without reservation their condemnation of the harsh political control exercised over Chinese writers since the fifties; nevertheless, I take issue with them on the importance of the "Talks" to literature.

Turning now to accounts more sympathetic to Mao's politics, we still find the same lack of detailed attention to Mao's literary theory. Jaroslav Průšek's monumental *Die Literatur des Befreiten China* (1955) devotes a full chapter to a discussion of the "Talks," but it is more explicatory than analytical and the perspective is more political than literary. Wang Yao's *Zhongguo xin wenxue shi gao* [Draft history of China's new literature] (rev. ed. 1954) provides a more rounded treatment; Wang elucidates the nature of the relationship between art and politics and echoes Mao in stressing the artistic need for reform of the May Fourth style of written vernacular. However, various discussions published in May 1957 in *Chinese Literature* and in Chinese literary magazines like *Wenyi bao* on the fifteenth anniversary of the "Talks," for example, are couched in very general terms, and post-Cultural Revolution articles, such as those in *Wenwu* in May 1972 on the thirtieth anniversary of the "Talks" or in *Shi kan* in May 1976, all choose to focus on contemporary politics rather than pursue the theoretical implications of their text.

In contemporary Western Marxist literary criticism and theory the contributions of Chinese revolutionary literature and literary criticism have largely been ignored, though the works of its two leading figures, Mao Zedong and Lu Xun, and of many others have long been available in Western languages. Some Western Marxists (Christopher Caudwell, Terry Eagleton) seem to assume the existence of only one kind of art as a topic for discussion, that is, the art of the elite culture (or even more narrowly, the art of Western elite culture) with which they themselves identify, and they disregard the cultural life of the little- or noneducated masses as being of no artistic interest. Ernst Fischer, for instance, speaks of a "contemporary problem: the entry of millions of people into cultural life,"[5] as if the Russian peasantry or the industrial West dwelt in some dark world where no cultural life could possibly exist. Others, like David Craig and Raymond Williams, broke through this conceptual limitation, and it is significant that these two critics are also exceptional in including modern Chinese literature and literary criticism in their investigations. Lu Xun and Mao, while conscious heirs to the elite classical tradition of their own country, nevertheless appreciated the diversity of currents within the bounds of traditional Chinese culture and drew attention to their artistic validity. Mao's appreciation of this diversity has, however, often been overlooked by Western critics (Solomon, Rühle) who have in other contexts quoted from the "Talks."[6]

In the face of this general inclination to regard the "Talks" as primarily a political document with little literary significance, it may seem foolhardy to insist that the "Talks" does have a specifically literary message worth examining in detail. My defense is twofold: since Mao is himself a literary figure of some importance in twentieth-century China, it seems worthwhile to follow up his published remarks on the nature and source of literature and the means of its evaluation; more importantly, it seems that a deeper understanding of the complex and revolutionary ideas contained in the "Talks" may lead us to the necessary analytical tools for a more fruitful investigation into contemporary Chinese literature.

According to Cyril Birch, the prevailing attitude among participants at the 1962 *China Quarterly* conference on Chinese Communist literature toward contemporary Chinese literature was "the 'particle of art' approach." The expression "particle of art" was derived from Pasternak: art is in this sense defined as "an idea, a statement about life"; in other words, an ideology. Pasternak also states, "I have never seen art as form but rather as a hidden, secret part of content."[7] In this definition, art approximates ideology, especially implicit ideology, and the "particle of art" is the detail that expresses the kind of ideology about life which Pasternak and the *China Quarterly* conferees find congenial. Birch notes that conference participants examined their literary texts with a view to exposing the "detail on the margin" that might contain this "particle of art."[8] Thus, with the outstanding exception of Birch's own article on the persistence of traditional storytelling techniques, the works that emerged from the conference concentrate primarily on the search for anti- or noncommunist attitudes in the texts chosen for examination. While there are signs that this approach is being discarded in the seventies, there still remains the question of what is to replace it. There is, for instance, the possibility that in the more favorable political climate of this decade the old attitude of political disapproval will merely be replaced by the equally unfortunate one of undiscriminating approval. Another possibility was offered by Birch at the conference: "If we study problems of literature at all, we must concentrate on works of art as the essence or basis. After we have done enough close observation of this essence, we may expatiate on the social significance and political connotations of the work."[9] This is a much fairer approach than the "particle of art" method, but is still conspicuously guilty of what Mao has constantly been accused of, namely, the lack of a sense

of the interaction between politics and art, or for that matter, between form and content in literary and artistic works. The "essence" of art may turn out to be a conceptual fantasy, a delusion that leads our research into a dead-end of unexamined prejudices about literature and art. Mao's "Talks" read in the context of modern Western literary criticism provides an alternative to the "essence" or "particle of art" approach by relating both form and content to specific audiences and their requirements.10

From the outset we are faced with the problem of which text to use. Mao spoke in Yan'an on 2 May and 23 May 1942, but despite subsequent conventional reference to the "publication" of his speeches that year, they were not actually published until 19 October 1943 in commemoration of the seventh anniversary of the death of Lu Xun. (The decision to publish at this particular time is likely to have been made for political rather than purely literary reasons.) During the forties and early fifties, the "Talks" was published in over eighty editions, all based on the same text. After the establishment of the People's Republic of China in 1949, Mao published a new collection of his pre-1950 writings, heavily revised; a further edition of his collected works, with an additional volume and in simplified characters, appeared in the sixties. All versions of the "Talks" published after 1953 are based on the revised text and are identical except for pagination. We can therefore distinguish two main versions: pre-1953 and post-1953.11 Of the pre-1953 text there are no published English translations that are both complete and accurate, and no complete translation is currently in print. The official Peking translation of the post-1953 text, published in 1965, is accurate and reliable, but rather stilted in places.12 For existing translations of the "Talks" and other writings by Mao on literature and art and a brief statement of my own policy as a translator of the pre-1953 text, see Appendix 3 below.

The differences between the two versions of the "Talks"13 may be categorized as formal or substantive, though the dividing line between these two categories is by no means always easy to determine.14 Under the heading of formal changes we may include such things as changes in punctuation or wording that do not alter the basic meaning but involve more vernacular or grammatically correct usages; the elaboration of geographic or political terms no longer meaningful to a post-1949 readership; and the attempt to "polish" the text by eliminating the occasionally coarse language of the original. The substantive changes are harder to summarize.

Viewed as simply a statement about the nature of literature and its
function in a revolutionary context, the revised version is more
rigid in its dialectical materialist analysis and yet broader in its
ability to appreciate popular culture. As an instrument of literary
policy, the revised text assumes a kind of historical ambiguity very
different from the clearcut circumstances of its initial presentation.
That is, some of the revisions indicate that a wider audience than
the workers, soldiers, and peasants of the original is being sought,
obviously in response to the historical and social changes that have
taken place; yet, the account of the historical determinants on which
his initial analysis is based is not simply updated in response to
these same changes. In general, the revised version is neither a
rewriting of past history in the light of fresh knowledge nor an at-
tempt to offer a new policy in terms of a new historical context: it
is instead an attempt to update a policy without reviewing the con-
crete historical conditions that gave it its validity. As a model for
literary analysis based on historical determinants, therefore, the
original text is more important than the revised version. Since the
comparison of two different versions of the same text is a useful
device for gaining a deeper appreciation of the real intent of the
author in either version, a detailed comparison of both versions at
specific points of literary or political significance can be very reveal-
ing, in regard both to what has remained unchanged and to what has
undergone revision. Finally, the historical impact of both versions
has been considerable, so that for a proper understanding of the
literature of the Yan'an period, when the influence of Mao's "Talks"
was deeper than at any subsequent time up to the Cultural Revolu-
tion, we must obviously refer to the pre-1953 versions, while for the
literature of the fifties and later we must look to both the later text
and to the changes in policy or thinking revealed by the revisions.

As for the possible sources of Mao's remarks on literature and
art, it is clear that much of what he has to say is derived from the
literary policies adopted in the Soviet Union and has more to do with
Leninism than with Marxism. As several Western scholars have
pointed out,[15] Mao has also incorporated into the "Talks" many of
the theories on revolutionary literature that had been circulating
in China since the mid-twenties, his criticisms of the Westernization
of Chinese writers in particular having been anticipated by Qu
Qiubai. The originality of Mao's thinking does not seem to me a cen-
tral issue, and I do not intend to pursue it further; nevertheless, it
is apparent that in some respects, such as the relative importance of

the audience (seen as an immediate, local, peasant audience), the political importance of literary forms, and the formation of literature in the individual mind, Mao goes beyond Qu and all other left-wing writers with the possible exception of Lu Xun.[16] The major reason for the importance of the "Talks," however, is that it embodies Mao's ability as a political leader to organize the loose body of current literary doctrines among the left in China, formulate them with sufficient clarity and understanding as to make them a comprehensive literary policy for the present situation, and see to their immediate implementation in Yan'an. In its subsequent enshrinement, in revised form, as a literary policy for the whole country and for all writers, regardless of political affiliation, the political importance of the "Talks" increased enormously, though it may be argued that its literary interest was diminished.

The political and social background against which the Yan'an conference itself was held, being familiar, of course, to the participants, was described in the "Talks" only briefly. As was generally accepted, Mao assigned the beginning of the modern literary movement in China to the "New Culture Movement," which attempted to overthrow traditional Chinese culture and which found its first political expression in the May Fourth Incident of 1919, when students, heading a short-lived coalition of small businessmen and workers, demonstrated against their country's inability to resist foreign intervention. This movement combined nationalistic feelings of anger toward Western and Japanese aggression in China with an enthusiastic internationalism that sought Western remedies for Chinese ailments; the rejection of traditional Chinese social and cultural values was also joined with attempts to reassess the tradition and extract its democratic and populist elements. In the twenties and thirties a vast number of new ideas on social justice, national liberation, and individual fulfillment jostled for supremacy in the minds of China's new young elite, while the economic and social condition of the great majority of the population continued to grow steadily worse. Attempts at reform by the Nationalist (Guomindang) government in the thirties served only to prove the inadequacy of its gradualist, piecemeal, and authoritarian measures. The radicalization of the educated youth over this period was reflected in a turn to the left in literature, and many of the most respected writers openly advocated a Marxist or communist discipline. The harsh suppression of left-wing activities by the government turned writers and students into revolutionary agitators and conspirators, living in constant expectation of betrayal, imprisonment, and

martyrdom. The pressure of Japanese aggression in China effected a truce in 1937 between the Nationalists and the Communists, but their uneasy alliance by the early forties barely concealed the mutual hostility of both parties. In Chongqing, the wartime government seat in remote Sichuan Province, the Nationalists ignored social reform and reserved their crack troops for the coming internal struggle. At the same time, hemmed in by both government and Japanese forces in the even more remote north Shaanxi town of Yan'an, the Communist party initiated wide-scale social experiments which both overturned existing social structures and mobilized the peasants for guerrilla warfare against the Japanese. To Yan'an, therefore, came the intellectuals from the cities, to observe and participate in a kind of social change that seemed the only path to a vigorous and independent new China. Some were old hands at revolution (though not especially successful at it), and some were stirred by frustrated patriotism and impatience at government corruption in the Nationalist interior. These people were needed in Yan'an for administrative and educational work, but conflicts soon arose between them and the Long March veterans in the party leadership. Following the particularly acute crisis in manpower, morale, and materiel caused by the Japanese campaigns of 1941 and the tightening of the Nationalist blockade, the party began in 1942 the movement to increase discipline and improve bureaucratic styles of work that became known as the Rectification Campaign. Responding quickly to the invitation to criticize work and lifestyles in Yan'an, the revolutionary writers became articulate critics not so much of themselves as of the party leadership. After two months of their forthright attacks in Yan'an newspapers, a meeting of writers, intellectuals, and leading party cadres was convened. Zhu De, commander-in-chief of the Communist armed forces, opened the conference, and Mao, party chairman and leading theoretician, addressed its first and last sessions.[17]

The account that follows here seeks primarily to examine the elements of literary theory that arise in the text of the "Talks"; it also touches on the political overtones of the Yan'an conference, the contributions of others both before and during the debates, and some effects of the conference and the "Talks." It assumes the reader's familiarity with the text, to which this account is more a commentary than an introduction. Not all of Mao's thinking on literature and art is explicit in the text, however, and in the discussion that follows I have read between the lines for Mao's

unspoken assumptions as well as to comment on his better-known propositions on the politics of literature and art. His speculations on the nature and origin of literature and art, for instance, seem to rest on an underlying conception of poetry as the paradigm of literature and art generally, a concept common in traditional societies and unsurprising in someone who himself wrote poetry. Many of the arguments raised in the "Talks" become clearer if we see them as referring primarily to poetry and as stemming from Mao's own practice as a poet. First, Mao describes literature and art (i.e., poetry) as basically the result of a mental process of "polishing" or refinement wherein the greater the degree of polishing the greater the artistic merit of the finished work. From this position, the writer or artist is seen as a craftsman or technician whose talent is improved by training as a social accomplishment, in contrast to the view of the artist as seer or extrasensitive being with unique insight into the workings of the universe or the human mind. It follows, then, that writers and artists have no special claims, *per se*, on privilege or moral responsibility, such as were made by Yan'an writers like Ai Qing and Wang Shiwei. Another traditionalist attitude shows up in Mao's lack of enthusiasm for May Fourth literature, a sentiment he probably shared with other educated people of his own generation. Like Marx and Engels, he was more interested in the masterpieces of the past than in the new works of the present. His favorite reading was traditional novels, and he himself wrote in Tang and Sung metres; moreover, his utilitarian approach to literature and art bears a strong resemblance to Confucius's instructions to his disciples. Mao's disdain for other writers, of a younger generation and different school of thought, also lies well within the tradition of Chinese men of letters. While the decision to discipline the Yan'an writers was a political one (and not necessarily Mao's alone), Mao could well have seen himself entitled by virtue of his senior literary status to legislate over the May Fourth writers. — None of the positions I have outlined here is overtly expressed in the "Talks," and Mao may have held them without having been conscious of doing so. Nevertheless, I believe that such interpretations or speculations help to explain both the text itself and its history.

* * * * * * *

Mao's introductory speech at the conference and his conclud-
ing remarks three weeks later both begin in a typically pragmatic
way. The Introduction commences with a statement of purpose,
which is the fairly limited goal of defining the relationship between
works of literature and revolutionary work in general. He sets
forth the specific context of this goal, which is a situation of pro-
longed civil war, armed revolution, and foreign invasion. In the
midst of these struggles, Mao is interested in literature only as an
instrument for inspiration and education. The Conclusion opens
with an even more specific description of the historical and literary
context, which carries the even clearer implication that since the
goals for literature depend so much on circumstances that are con-
tinually liable to change, the goals themselves can hardly be fixed
or absolute. Mao is particularly insistent on the uselessness of
textbook definitions of literature and art. Definition-seeking was
a favorite May Fourth approach to literary research, especially in
the period from 1917 to the early twenties, an approach that some-
times bordered on the ridiculous in its intensity and may have had
harmful effects on the new literature (for example, encouraging a
tendency toward remoteness from reality). We may note, however,
that the pragmatism recommended by Mao implies a theoretical flex-
ibility which was in practice replaced by a fairly rigid and literal-
minded dogmatism, a transition over which Mao himself presided and
which, on the whole, he did little to discourage. His ambivalence
on the question of flexibility is borne out by the highly selective
and limited revisions made in the "Talks" in the early fifties, which
ignore the fundamental difference in the specific historical context.

The structure of the Introduction is rather loose, with five
topics (position, attitude, audience, work, and study) that have no
obvious conjunctive relationship. (In the Conclusion, Mao combines
the first three topics into one, namely, the problem of determining
the audience, and the remaining pair, work and study, disappear
as separate topics.) Under the topics of work and study in the
Introduction, Mao defines the relationship between literary studies
on the one hand, and organizational or other work and the study of
Marxism on the other; in each case, literary studies take a second
place. To emphasize the point, Mao repeatedly refers to writers and
artists as "workers in literature and art" throughout the Introduc-
tion and the Conclusion. The section on work also contains Mao's
well-known anecdote about his early attitude as a would-be

intellectual toward physical labor and is the central part of the Introduction.

It is difficult for Westerners to appreciate the depth of the distaste for manual labor that the new intelligentsia inherited from the old gentry class. In the West it is not uncommon for writers or intellectuals to have worked with their hands, if not for a living then for a temporary need or as a hobby. (It is unthinkable, by contrast, that any Chinese statesman from Confucius to Chiang Kai-shek could boast that his hobby was bricklaying.) In the twentieth century, it has become almost obligatory for an aspiring writer to serve an apprenticeship as stevedore, farmhand, short-order cook, and taxi driver, but we look in vain for signs of this kind of personal experience in May Fourth literature. Instead we find what has been called the "rickshaw boy mentality," or over-abundance of stories and poems about coolies, servants, and rick-shaw pullers, the only members of the working classes with whom writers come into direct contact. Poverty is a frequent element in May Fourth writing, but the possibility of an intellectual seeking factory work or any other kind of manual labor never seems to occur to the student or writer protagonist, or to the author.

The new intellectuals were in fact distant both from the reali-ties of the Chinese present and its past. Their gentry forebears at least maintained a kind of contact with the peasantry impossible for the urban-centered and Westernized intellectuals of the twentieth century: no longer were there shared assumptions on social values and morality, which enabled certain kinds of popular oral literature and performing arts like fiction and opera to be enjoyed by all social classes. As Paul Cohen described a situation that began al-most a hundred years before, the acculturated Chinese of the Western-controlled littoral were to prove ineffective agents of change in the hinterland. Even if writers came from fairly humble back-grounds in the interior, Mao points out that by the time they be-come writers in the cities, they have already been "estranged" from the masses. Mao's criticism of May Fourth writers on this point is not only accurate but apposite. By and large, May Fourth writers wanted to reach out to the people, but found themselves unable to do so. In a very poignant phrase, Mao calls them "heroes without a battlefield, remote and uncomprehending." He does not criticize the goals of May Fourth writing, but rather its failure to achieve a more gritty kind of realism and a vitality based on a knowledge

of reality as experienced by China's masses— not merely on student enthusiasm.

The main body of the "Talks," the Conclusion, is also divided into five sections. Its most striking feature is the way in which Mao's attitudes have changed or hardened in the intervening weeks. Instead of being swayed by the arguments of the Yan'an writers present at the conference, Mao has become more certain of the correctness of his own views and the harmfulness of the opposition. He has also come to see, more clearly and precisely than before, the source of the basic problem. Instead of the five topics of the Introduction, with their fine distinctions between position, attitude, and audience, Mao has narrowed his focus to the basic and essential problem: the question of the audience. All else is regarded as dependent upon this; the first problem to be solved is whom we serve and how we can best reach our audience. In taking this stance, Mao came remarkably close to some recent preoccupations of modern Western literary criticism.

In the history of the formation of literary theory in both China and the West, the first stage consisted primarily of an examination of the structure of the literary work itself: rhetorical devices, genre distinctions, rules of prosody, and so on. In the West at least, these studies gradually developed into a search for the basic nature or "essence" of literature and other forms of art, and the attempt to isolate and define the essence of art or the essence of beauty in metaphysical terms ultimately led to the sterility of neo-classical theories. The romantic movement of the late eighteenth and early nineteenth centuries shifted the emphasis somewhat away from the art object to the artist himself. The nature of inspiration became a favorite topic, together with such related themes as the role or function of the artist in society or in the universe at large. Biographical studies of writers and artists became popular as the artist appeared as an independent member of society materially and intellectually. The growth of realism in literature or materialism in social philosophy subsequently led to an emphasis on the influence of the environment on the artist or writer, and conversely, the social function of art or the influence of art on society. When China first came into contact with Western literary theories in the second and third decades of the twentieth century, the elevated position of the artist as a focus of literary interest was seen as compatible with the traditional role of the scholar/writer as social leader. Traces of such unconscious gentry attitudes, in spite of objections raised

by Lu Xun and others, can be found in the exalted description of the writer as a "standard-bearer of the revolution," which was written into the manifesto of the League of Left-wing Writers at its inauguration in 1930.

The growth of interest in Western literary studies regarding the audience for literature and art, sometimes known as reception studies or included in the "sociology of literature," is a relatively recent phenomenon dating back perhaps only twenty years or so.[18] The fragmentation of the reading audience into sectional groups in the nineteenth century, the new awareness of "impact" and "response" that arose from new theories of psychology and physics, and the growth of democratic and left-wing groups seeking wider audiences for serious literature are among the causes for this trend. Studies in the sociology of literature by no means proceed inevitably or exclusively from a Marxist standpoint. As a contemporary Marxist writes, "There has been some excellent work in this field, and it forms one aspect of Marxist criticism as a whole; but taken by itself it is neither particularly Marxist nor particularly critical. It is, indeed, for the most part a suitably tamed, degutted version of Marxist criticism, appropriate for Western consumption."[19] Indeed, little attention is given to the question of audience in the writings of Marx and Engels: both seem to envisage a cultural continuity with the classics of the past and present, as workers of the future achieve leisure and education under a socialist system.[20] Marx's "characteristically intelligent and informed incidental discussions of actual literature are now often cited, defensively, as evidence for the humane flexibility of Marxism, when they ought really to be cited (with no particular devaluation) as evidence of how far he remained, in these matters, within the conventions and categories of his time."[21] When Marx and Engels called for a new literature to serve the interests of a new class, they gave no hint as to its basic nature. Lenin shared Marx's respect for the European literary heritage and also had some understanding of the need for the proletariat to develop its own literature.[22] This need was certainly acknowledged by left-wing May Fourth writers like Qu Qiubai and Guo Moruo,[23] but it was Mao who brought the audience to the forefront of the discussion in China, and his analysis of audience needs and the influence of audiences on writers remains one of the most important and innovative sections of the "Talks."

In his Introduction, Mao still sees the audience as a reflective and passive element, in contrast to the writer, the active element. He appeals to writers to write for the audience in the base areas, trying to encourage their compliance by stressing the greater size of the Yan'an literate audience in comparison to the audience in

Chongqing and the potential influence and significance of this audience in Chinese history. He also indicates an audience among the illiterate, but does not stress it at this point. According to the Introduction, writers are obliged to get to know the masses, but their duty is to educate them rather than simply to appeal to them. The only role given to the audience is a passive one: they can reject writers who try to put on airs. Even the term used for "audience" shows its passivity: *duixiang* or "opposite image," "object of attention"; alternatively, *duixiang* is also defined in the text as "whom we give [works of literature and art] to look at."

The discussion of audience in section one of the Conclusion almost reverses this relationship: the writer loses his primary importance, while the audience gains immensely in relative status. The relationship is now defined as one in which the writer serves the people. Literature and art are described as "being for the masses" *(wei dazhong)*, and there is no longer any distinction made between position, attitude, and audience; there is no longer even the theoretical possibility that writers may be on the side of the masses and yet write for a different audience. "To be for" here includes two concepts: to be in the interests of (the masses) and to take (the masses) as an audience.

Under this new definition of the relationship between the writer and the audience, Mao formulates two new demands on the writer: the writer must now produce works welcomed by the masses, and must also learn from them and be guided by their "budding forms of literature and art." In the passage concerning these "budding forms," Mao accuses some writers of adopting a patronizing attitude toward popular forms of literature and art: for the most part, he claims, they hardly bother to notice them at all, and if they do, it is often for the wrong reasons, like searching out the more backward elements of popular art for use as embellishment in their own work. (Mao is here probably referring to the folkloristic studies popular in Peking in the twenties, and writers like Shen Congwen.) The "budding forms" are enumerated as wall newspapers, wall paintings, folk songs, folk tales, and popular speech (the last item omitted in the revised version). The most noticeable omission is village opera, whose praises had been sung by no less a figure than Lu Xun; the forms of village opera around Yan'an were still considered too backward to reform and were identified more with the interests of the local elites than the masses. (In spite of persistent attempts after 1942 to weed out the most reactionary elements in plots and staging, Peking and other regional

opera forms continued into the sixties with traditional stories of prime ministers and generals, scholars and ladies, ghosts and demons. The transformation of these characters into worker, peasant, or soldier protagonists had to wait another twenty years for simple antifeudal attitudes to be refined sufficiently to deal with this hitherto intractable mainstream genre of popular culture.)

The important implication of this passage lies not so much in the forms that are mentioned but in the elevation of the masses to equal or at least active participation in the creation of works of literature and art. Their participation has two facets. On the most fundamental level, the masses are seen as spontaneously producing their own forms of literature and art, which professional writers and artists must use as a basis from which to proceed. (We are evidently still in a stage before the masses can produce their own finished products.) Among these forms, Mao includes popular speech, which he sees as more lively and hence more artistically interesting than educated speech. (Although popular speech is omitted from the revised version at this point, other lines are added elsewhere to indicate its important role.) What is most strongly implied here is the validity of popular forms of literature as literature. The masses may be uneducated, but they are not idiots to be written down to; their art forms are primitive, but they still constitute art. Mao therefore recognizes their rightful demand to force writers to take into account their literary expectations, conventions, and beliefs, along with the fact that writers in practice invariably shape their means of expression with a preconception, however vaguely envisaged, of a given audience, however miniscule. Wayne Booth, a modern American critic, in analyzing the use of rhetorical devices similarly came to the conclusion that "the ultimate problem in the rhetoric of fiction [i.e., the way in which the author chooses to narrate the story], is then, that of deciding for whom the author should write."[24] Booth would hardly agree with Mao that the undifferentiated masses had a supreme right to form this audience and exercise exclusive rights over authors, but both Mao and Booth were equally impatient with such formulations as "the author writes for himself." Booth emphasizes the essential if sometimes unacknowledged or denied wish of the author to communicate, while Mao writes with a satire equal to Lu Xun about those who maintain that their writing has no audience in mind.

The next major topic raised by Mao in section two is the source of art. It arises in the context of a familiar left-wing problem: whether to concentrate on producing the kind of art that

would reach the widest possible audience or on an art that raises the
cultural level of the audience by presenting artistically advanced
material. Mao's main argument is that both advanced and elementary
forms of art come from the same source, the life of the people. The
paragraphs dealing with the source of art are not only interesting
in themselves, but are among the most heavily and significantly re-
vised passages in the text. A comparison between the two versions
elucidates the basic meaning of both.

In the first version, Mao states that "rich deposits of litera-
ture and art actually exist in popular life itself," and goes on to say
that "life itself is literature and art in their natural form." The
theory develops as follows: "literature and art in natural form" are
lifted onto a "conceptual level" after being "reflected and processed
in the mind of the writer." The nature of the final product, con-
ceptualized literature and art, depends on the quality or nature of
the writer's mind and on the amount of processing given it by the
writer; for example, a revolutionary writer will produce revolution-
ary literature, and the more processing the writer devotes to his
art, the more polished and advanced in quality the literary work
will be.

In the revised version, there are two significant changes.
First, "literature and art in natural form" are reduced to "the raw
materials of literature and art," which are to be found not in "popu-
lar life" but in "a specific social life" (a narrower focus requiring
a definite social framework). Second, this "raw material" is only
"reflected" in the mind of the writer, who then "creates" the fin-
ished product. The replacement of "process" by "create" seems to
divert attention from technique to originality (creativity). However,
the Chinese word *chuangzao,* which was adopted to translate the
English term "create," does not necessarily carry the same over-
tones of originality and individuality that the word possesses in
English. It is possible that Mao simply wished to use a more fashion-
able or critically acceptable word than the rather humble "process";
nevertheless, there remains some de-emphasis on the idea of the
finished product being improved by lengthy processing. The sub-
stitution of "the raw materials" for life itself may indicate that Mao
wanted to adopt a more conventional literary vocabulary, but it also
suggests a more narrowly materialistic and mechanistic view of litera-
ture. As Schram remarks, the concept of life itself as a kind of
living art is highly poetic,[25] and reminiscent of early German roman-
ticism and expressionism rather than realism.

What remains unaltered in the revised version is more significant than what has been changed. In most left-wing criticism, particularly of the twentieth century, attention is given primarily to the influence of the environment on the writer; specifically, the current modes of production in the society and the social class into which the writer is born and in which he lives. Mao manages to avoid this kind of reductionism by stressing the role of the mind of the individual writer—either reflecting and creating or reflecting and processing, but in both cases decisively influencing the finished product. It may be argued that in Mao's view, the mind of the writer (consciousness) is in any case determined by the social environment (being), but by discussing the whole issue in terms of "mind" rather than environment, Mao seems automatically to imply and encourage the personal response to life (the raw material of literature), and to allow considerable room for the play of individual imagination and technique.

In general, this passage seems to indicate that Mao's conception of the source and creation of literature derives less from standard literary theories of East and West than from his own experience as a writer and poet, and that the revisions were probably made on the advice of some more conventionally-minded professional like Zhou Yang. For example, in the pre-1953 versions, Mao uses the expression "proletarian realism," which had briefly been in use in the Soviet Union but had been superseded since the early thirties by "socialist realism."[26] This suggests that Mao was not particularly well versed in Soviet literary criticism, or at least not up-to-date in its current usages.[27]

The difference between the earlier and later versions of the "Talks" is particularly striking in the passage in the same paragraph about using literature from the past or from foreign countries as a guide or basis for current literary production. Mao's initial response is to assign a very minor role to these two possible sources of literary creation in an obvious reaction to the two currents of Westernization and neo-traditionalism in May Fourth writing. In the fifties, however, Mao's attitude softened considerably on these two points. The literature of "dead people and foreigners" is revised to read the literature of "the ancients and foreigners," and the initial instruction to "absorb these things in a discriminating way, using them as models from which we may learn what to accept or to reject when we process works of literature and art" becomes an instruction to "take over all the excellent tradition in literature and art,

critically assimilating whatever is beneficial and using them as exam-
ples when we create works."

There is little doubt that such a critical attitude toward the
overemphasis on existing literary models in May Fourth writing was
justified, but the question remains why these remarks were modified
so greatly in the fifties. The reasons seem to be political rather
than literary. First, the Communist Party was no longer a band of
rebels, opposing the ruling classes and the culture that supported
them, but the new ruling group and therefore themselves heir to
that culture. Moreover, it was now more important than ever to
unify the whole nation by appealing to a shared national pride in a
shared heritage on the broadest basis possible. In addition, there
may have been some influence from the Russian example, where na-
tionalism had been strongly encouraged since World War II, and
"rootless cosmopolitanism" had become a favorite term of abuse for
the remnant traces of Western or Jewish internationalism.[28] How-
ever, even more interesting is, again, what has not been changed:
that is, that in both versions no distinction is made between foreign
models and models from the past, either in potential harmfulness or
in excellence. For "foreign," of course, must include Soviet models,
and at this stage there could be no public criticism of the Soviet
Union. Nonetheless, the statement stands that foreign influences,
just as much as native influences from the past, must be considered
important, if only secondary, in the creation of China's new
literature.

To sum up this portion on his argument, Mao asks what, after
all, is the difference between literature and life? The original answer
is that literature is more organized, more typical, more ideal, and
hence, more universal than life. The revised answer kept most of
these attributes, but replaced "organized" with "on a higher plane,
more intense." The term "organized," like "processed," is a speci-
fic, concrete term implying reliance on structure and technique in
literary creation. The substitute terms, on the other hand, are
vague to the point of being quite meaningless, an echo of an expres-
sion used by Lenin. But we may assume that apart from invoking
the authority of Lenin (though he does not cite Lenin by name), Mao
wanted to de-emphasize again the importance of technique or pro-
cessing in literature. This becomes even clearer from the revisions
to the next paragraph, in which Mao returns to the original problem
of deciding between literature that reaches wider audiences and
literature that raises standards.

We have already noted the suggestion, especially in the first
version, that the greater the amount of processing, the greater the
literary merit of the finished product. Mao now makes this point
explicit. He distinguishes between two levels of literature: a low
level, where the processing has been "limited and crude," and a high
level, where the processing has been "extensive and skillful." In
the revised text, the low level is described simply as an "elementary"
level and is characterized as "plain and simple," while the high level
is still "high," but merely "more polished." At the same time, the
workers, peasants, and soldiers, who were first described as "illi-
terate, ignorant, and uncultured," are in the revised version only
"illiterate and uncultured"; their struggle is no longer just "bitter,"
but "bitter and bloody." (The latter change seems particularly un-
historical: a reminder to the present rather than a description of
the past.)

Having described these two levels of literature as related
rather than separate entities, Mao acknowledges in the first version
the need among cadres for more polished literature, on a level that
the uneducated masses cannot be expected to handle. However, in
the revised version he omits the reference to this need, so that the
potentially controversial question of what a cadre literature might be
like is averted. A little further along, Mao makes a passing remark
to the effect that low levels of art are not necessarily linked with low
standards of taste; in the revised text, "low levels" are euphemized
into "elementary levels" and the remark about taste is omitted altogether,
possibly because Mao felt the very implication to be offensive.

There is a general and very widespread tendency among
literary critics and scholars in both the East and the West to regard
good or bad taste in art as a function of social class or education.
The fallacy of this can easily be demonstrated by comparing, for
example, the reading habits of a Western literate proletariat with
those of the middle class. Without even going into definitions of
"taste" or its standards, we find a range of interests in both
classes going from the most ordinary kinds of pulp literature to
the established classics.[29] In the forties, Mao evidently felt the
need to make a similar point, although the reason for its later omis-
sion is unclear.

The even greater fallacy that popular forms of art are technically
more simple than forms of art produced by professional writers or schol-
ars ignores the fact that popular forms of art are typically highly

complex and stylized in structure. Either because his own literary
appreciation of this point increased during the forties or because he
tried to discard his elitist attitude for purely political reasons, Mao
modified his views on the relationship between technical processing
and popular literature, as shown in the revisions described above.
The revisions also seem to indicate that Mao modified his views on
the relationship between technical processing and the quality of the
finished product in an opposite direction, that is, to reject the view
that elaborate technique is a prerequisite for literature of high qua-
lity. Unfortunately, there is not a great deal of detail about either
point, and our conclusions must remain very tentative.

We may now ask what is the ultimate difference Mao sees be-
tween "high" art and "low" art. On one level of interpretation, we
might be tempted to conclude that his high art consists of the art
of feudalism, while low art is the art of the proletariat, with the art
of the bourgeoisie occupying an intermediate position. A more dia-
lectical variant of this model would have the art of the bourgeoisie
deposing or engulfing the art of feudalism as the bourgeoisie gains
political ascendancy; similarly, the art of the proletariat would rise
to the position of high art during the period of the dictatorship
of the proletariat. There is, however, no evidence either in the
"Talks" or in any other published remarks by Mao for such a sche-
matic argument. It seems more likely from the text that both high
and low art can and do appear within the broad category of litera-
ture and art for the masses and are not inherently linked with class
or class struggle. One distinction that might be drawn, which
would seem to complement the development of Mao's thoughts on
this topic, would be that low art makes relatively few demands on
an audience by presenting familiar material in familiar ways, whereas
high art could present material in relatively unfamiliar ways, intro-
ducing new techniques, rare or unusual vocabulary, unexpected
imagery, or new modes of thought. A more educated audience could
respond to such challenges in a way difficult for those whose ex-
perience is limited, but there need be no implication as to the audi-
ence's level of taste ("high" art may well be in bad taste) or intel-
ligence, or to the extent of stylization in the work presented. In
addition, the only limiting factor in terms of choice of subject matter
or genre would be the level of expectation of the audience. In such
an argument Mao's poems could share a place in literature for the
masses, along with the novels of Hao Ran or contemporary *quyi*
(minor musical/theatrical arts) performances: all three share con-
siderable technical skill and a revolutionary ideology, but the

language and imagery of Hao Ran's novels are more innovative than
quyi peformances, and Mao's poems are more innovative than the
novels. This approach obviously leaves some questions undecided,
but it may prove useful in dealing with various trends in modern
Chinese literature.

Returning to the strategical problem of choosing between
literature that reaches a wider audience and literature that raises
artistic standards, Mao seems to have settled on the role of synthe-
sizer by pointing out the need for both types as well as their prac-
tical interdependence. By emphasizing both the common source and
common goals of both kinds of literature, he is able to effect not
merely a commonsense compromise but a genuine theoretical synthe-
sis. A less attractive side of Mao, that of the authoritarian disci-
plinarian, also emerges in the final paragraphs of section two:
"Once we agree on the fundamental goal . . . all our activities in
literature and art should serve this goal. It would be wrong to
deviate from this goal, and anything at variance with it must be
revised accordingly." Mao defines the goal in terms of concrete
historical conditions, and his concept of the source of literary in-
spiration and the process of literary creation, especially in the pre-
1953 versions of the "Talks," is well-constructed and expressed,
and pertinent to the problems of the contemporary literature. How-
ever, his account of this source and process is flatly universalistic
and seems to rule out the possibility of other approaches being
equally valid for different purposes or periods.

I have quoted above T. A. Hsia's statement that "one doesn't
have to quarrel so much with Mao's theory as with the fact of control."
It is this part of section two that tries to justify both the universal
applicability of Mao's literary thinking and the "fact of control."
The control described here relates only to deviations from agreed-
upon goals, but even this limited kind of control is potentially harm-
ful. The demand for a single goal for various kinds of activities
ignores the value of the differences themselves between things. To
give just one example, during times of warfare, national leaders can
be expected to appeal for highly patriotic forms of literature, while
writers may favor a kind of brutal realism. But to the soldier in the
trenches, whose actual needs or wishes are rarely taken into account
by either group, sentimental and idyllic literature, or literature con-
cerned with personal, private feelings, may answer his needs more
properly. To demand that all literature serve the revolution easily
shades off into the demand that all literature be revolutionary, just
as rigidity over goals easily extends to rigidity concerning ways to

achieve those goals. Some effects of the authoritarianism in this
and other parts of the text are described below.

In section three, which concerns the relationship between
politics and art in general, Mao states that in the world today, there
is no such thing as literature and art independent of politics, and
that where classes exist, art follows the political demands of its
class. He then further asserts that not only does literature in fact
obey politics, but also that it should do so— thus, writers are under
a specific obligation to discharge certain responsibilities to the
masses and to the revolution. The sentence in which these two con-
tradictory ideas appear is omitted from the post-1953 text, as if Mao
himself was dissatisfied with the confusion he had created, but the
underlying sentiment is retained. Along with the general theoreti-
cal weakness occasioned by Mao's wavering between objective obser-
vation and normative projection, the section also constitutes the
furthest deviation from a traditional Marxist attitude toward the
relationship between art and society or art and politics.

The scattered remarks on literature and art in the writings of
Marx and Engels are generally ignored by Mao, either because he
was unaware of them or because he dismissed them as impractical or
unsound.[30] The fact that Marx and Engels themselves failed to pro-
vide a systematic text on problems of literature and art has not pre-
vented others from producing various theoretical constructs under
the name of Marxist aesthetics. The basis of most Marxist theories
has been the statement in Marx's preface to his *A Contribution to
the Critique of Political Economy,* to the effect that the economic
basis of society determines its ideological superstructure, and that
"being" therefore determines "consciousness."[31] According to this
argument, literature and art, as part of the superstructure, would
be determined by the economic base; the relationship between litera-
ture and politics, both parts of the superstructure, is not elabo-
rated on. Marx himself substantially qualified the economic deter-
minism of this approach, especially in regard to literature and art,
in his draft introduction to *A Contribution.*[32] Since it was not
published until many years after and is only in draft form, his
qualification has frequently been overlooked. Engels also warned
against economic determinism in regard to literature, and in addi-
tion denied that the writer was obliged, in the present stage of
social development, to take a partisan stand in his or her writing.[33]

It is Lenin rather than Marx or Engels who is chiefly respon-
sible for the concept of art as a political weapon in class struggle
and its further development into the more questionable concept of
art as an organizational tool of a political party. Mao twice quotes
him to the effect that literature is merely a cog or screw in the revo-
lutionary process. It has been claimed that Mao misquoted Lenin by
reading "literature" as "fine literature" rather than the "Party litera-
ture, i.e., Party press" of the original context. A close reading of
Lenin's complete text, however, indicates that he was referring to
"fine literature" as much as any other kind, but that his talk was
directed only at writers within the party and party sympathizers.
His own literary tastes were highly cultivated along traditional
lines, and he readily conceded that "cog" was a lame comparison for
literature. Like Mao, Lenin was writing at a time when the party
was an outlaw, a tiny fragment of society seeking to overthrow the
state and its whole apparatus of legal and cultural legitimacy: the
party's weapons were body-and-soul exhausting dedication and
voluntary acceptance of internal discipline. Unlike Mao, when his
party finally seized state power, Lenin made no immediate attempt
to impose party discipline in the arts as a matter of state policy,
as he was sometimes pressed to do by more radical artistic groups.[34]

The question of Marxism and the arts became a crucial issue
only after the establishment of communist state power, and was one
for which little guidance could be found in the Marxist texts them-
selves. In Russia, however, the issue of art and politics already
had a long history of theory and criticism: Lenin had developed a
tradition begun by Belinsky, Dobrolyubov, and Chernyshevsky,
and Zhdanov took Lenin's ideas a step further.[35] The subordination
of literature in the Soviet Union to the service of the state took
place under Stalin and Zhdanov with little theoretical justification
from classical Marxism. In China there had been a long tradition of
active involvement in literature by political figures, from rebels to
rulers, and while the actual power of the state to direct the course
of literature had been limited, its moral authority or responsibility
could be justified by appeal to Confucian tradition. It seems that
the position adopted by Mao was more a practical than a theoretically
plausible one; it would indeed be very useful to a party or ruling
class to be able to bend literature to serve its own needs.

Mao at least avoided the later vulgarizations of Marxist theory
by Krushchev, who excused the current "backward" state of Soviet
culture by referring to the country's still low living standards, and

predicted a steady rise in quality as the material life of the people improved.[36] Mao showed a tendency in sections two and three of the "Talks" to regard literature of the feudal, landlord, and bourgeois classes as qualitatively higher than the literature of workers, peasants, and soldiers, presumably because of the higher living standards enjoyed by the upper classes, but he did not try to rank these literatures in order of merit according to modes of production or material conditions, and that tendency is largely eliminated from the revised text. While Mao stood firm on the issue of political control over literature (whether as a fact of political history or as a matter of party policy), he does not seem to have embraced the economic determinism of some Marxists. Mao tries to make party political direction over writers more acceptable by here defining politics as mass politics and not the maneuvering of small groups or of individual politicians. Nevertheless, he makes it clear that mass politics are only made vocal by a small group, and since this small group now consists of communist, politicians and not old-style careerists, it may be trusted to express the true needs of the masses. He implicitly rules out the possibility for writers to be their own judges of mass political needs.

In the context of the May Fourth movement and the critical political situation in China, and considering the limited audience he was addressing, Mao is to a large degree justified in asserting the writers' political responsibilities. May Fourth literature may have encouraged students and members of the petty bourgeoisie to support the revolution, though there is not much concrete evidence to substantiate this. On the other hand, this Westernized literature certainly did not reach the great numbers of Chinese people who were most heavily burdened but whose power of resistance was low. It was most urgent that these people be persuaded or educated into rebellion and that their general level of consciousness be raised. The May Fourth writers who had come to Yan'an could well have accepted Mao's criticism as deserved.

Throughout this section, Mao hardly bothers to establish the point that literature can exert influence in the political sphere or function as a weapon of class struggle since his audience is all agreed on that. It is the crucial question of party direction or control that is at issue. In this period of actual and acute peril, party direction or control might be a necessary discipline. However, this same text, unchanged in this regard even after the 1953 revisions, was used after 1949 as a literary policy for the whole country, a policy at once exclusive, binding, and universal. It seems in order

for a political party to require its members to follow a particular
line, and it also seems in order for the leadership of a country
to urge its citizens to consider the whole people in their work. But at
no point is Mao able to justify the total submission of all writers from
whatever social class or group to the political demands of one class
alone, as interpreted by a small minority claiming to represent that
class.

Section four continues the same theme of the relationship be-
tween literature and politics, but in what seems to be a way more
readily justifiable by reference to actual conditions. The general
problem is that of evaluating works of literature and art; which
criterion, the literary or the political, does in fact come first in
literary evaluation, and what is the relationship between the two
criteria? On the first question, Mao is quite definite: although the
substance of both criteria differs according to social changes, their
relationship is invariable—in every class and in every society, poli-
tical criteria are always placed ahead of artistic criteria.

To many Chinese and Western readers, the blunt certainty of
this statement seems a deliberately offensive attack on their own
artistic sensibilities and fair-mindedness, and it would not be diffi-
cult for such readers to produce examples to prove Mao wrong.
Nevertheless, as a general statement it is a very profound truth
that just as a work of literature must be considered in terms of its
rhetorical acceptability to its audience, its political acceptability to
different audiences must be taken into account. We may be initially
attracted to a work of art for its beauty of form or skillfulness of
technique, but unless the basic values it represents are consonant
with our own, it will not stick with us and become a part of our
lives, no matter how skillfully it is presented. In the first place,
there is the problem of comprehension, our understanding of the
allocation of values within the work itself and the associated sym-
bols; more important is the conflict that emerges in resistance to
the author's demands on our sympathy. The tendency toward moral
nihilism in literary criticism has been vigorously opposed by critics
ranging from I. A. Richards to Wayne C. Booth; the positions taken
by Mao and Booth are again remarkably similar. One excellent exam-
ple of the priority of political criteria is the response of most Western
observers to contemporary Chinese literature: discussions about
"revolutionary model operas," for example, tend to criticize the use
of stereotypical, black-and-white characters or stories, which is
hardly relevant considering the nature of the genre from which these
operas have sprung, Peking opera itself. It may be objected that the

stereotyping in "revolutionary model operas" is not an artistic re-
sponse to the demands of the genre itself, but is a political demand
imposed on all literature and art, especially since the Cultural
Revolution. This is to a large extent, though not entirely, true:
the feature films that appeared in the aftermath of the Cultural
Revolution, while avoiding the predominant "middle characters"
(people who display both good and bad characteristics) of the fifties,
did allow more realistic and varied portrayals than the model operas.
The question of stereotypes is not simply a problem of content or
form considered in isolation, nor is it identical with politicization in
art. Stereotyped characters engaged in an eternal struggle between
good and evil are a feature of almost every kind of popular art, from
folk ballads and fairy tales to comic books and television series, and
even of certain stylized art forms considered "high" in the Western
tradition, like ballet and opera. We do not object to stereotyping
itself, if the genre assumes it, but to the identifications of good and
evil that conflict with our own.

Again, as in section three, Mao has a tendency to stray from
description to prescription in statements that the bourgeoisie always
rejects writers, whereas the proletariat must reject at least some as-
pects of bourgeois art. If we accept that the ruling ideology in any
age is the ideology of the ruling class, and that the ruled are there-
fore to some extent forced to accept that ideology, Mao's formulations
are more logical.

A secondary topic in section four is the relationship between
form and content. Unfortunately, Mao's treatment of this relation-
ship is only cursory, and it is not clear when he calls for their
unity whether he really means their interdependence or their equi-
valent importance. In one formulation, he seems to point to the
latter, more mechanical kind of "unity," i.e., "high quality artistic
form" plus "correct content." The problem is compounded by the
assumed formulas "form = art" and "content = politics"; elsewhere,
however, "art" is also used to refer to the work of art as a whole,
or "form + content." Yet, in other passages, Mao is obviously con-
scious of the political nature of form or technique, such as the need
to use the "budding forms" produced by the masses and the need
for the masses to develop new literature along their own lines. Mao
has been accused of being ignorant of the true relationship between
content and form, particularly when he speaks of using old feudal
forms and filling them with new content. In fact, Mao's actual for-
mulation here is "restructuring them and filling them with new

content," a process that evidently implies a change in form along with the new content. Conversely, it seems that Mao's remarks on the hierarchy of criteria do apply to Western critics who persistently ignore the artistic significance of Mao's literary theories.

Turning to current practice in literary criticism, Mao deals with some specific questions raised in the debates, which took place before and during the conference. The points raised during the conference have come down to us only in Mao's one-line formulations, and in some cases at least, it is possible that Mao deliberately phrased these points so as to make them seem naive or ridiculous (for example, the supposed demand for fifty percent praise and fifty percent criticism for every literary work). The arguments and criticisms voiced before the conference, however, are available, and we can see that they were in fact largely concerned with philosophical or ideological attitudes and political needs, again bearing out Mao's emphasis on critical priorities. The arguments concerning exposure, the essay form, and the Lu Xun style, for instance, relate to content (that is, the target of satire or criticism), and not to formal techniques.

A more interesting argument develops in regard to the final point raised by the dissident writers, the question of the "mistake of the dialectical materialist method of creative work." This method, a transplant from the Soviet Union, was briefly popular in China in the thirties before it was discarded as too rigid in its effect;[37] it was also discarded in the USSR. The "dialectical materialist method" required every work of literature to exhibit both the processes of decay and growth in society. It is possible that Mao was not really familiar with this kind of writing, which may not have circulated much outside of Shanghai, since he does not seem to address it in any precise way. His answer, however, is significant in its bold denunciation of all previously existing and current literary styles, from "feudal" through "liberalist" to "decadent." About the style of the future, which is to flourish in the aftermath of general destruction, Mao is reticent. Although Mao twice mentions realism or socialist/proletarian realism in this speech as the required literary style, he does not define it and does not display any great enthusiasm for it. In an interesting parallel, we may note that Marx never backed realism as the literary style of the future, and it has been conjectured that Engels only took up the question as a courtesy to his correspondents.[38]

The remaining arguments in section four fall into two broad categories, namely, party discipline and basic ideology. Perhaps the most pressing demand made by the Yan'an writers was for the freedom and the right to criticize shortcomings within the party. Two of the most frequently cited of the essays or *zawen* that preceded the debates, Wang Shiwei's "Ye baihehua" [Wild lilies] and Ding Ling's "San ba jie yu gan" [Thoughts on March 8], do not touch on literature or writers in any way, but are direct social and political criticisms of life in Yan'an.[39] Wang endorsed what he saw as general criticisms among young people in Yan'an that the party cadres fell far short of communist ideals, that they regarded themselves as a race apart from ordinary people, and were permitted special privileges in regard to food and clothing (privileges also enjoyed by intellectuals, as Wang frankly admits). What particularly incensed Ding Ling was the party's backwardness in regard to sexual inequality: the old male attitudes still persisted and made life difficult for women on all levels of party and social life.

There is no doubt that these criticisms were based on fact and that Mao knew it; the unsatisfactory behavior of cadres was precisely the target of the Rectification Campaign. But to Mao this was a problem of intraparty discipline, a problem to be handled by the party and not one of major concern to writers as such. In one sense, writers were hardly qualified to mount such an attack, since they too suffered from the same shortcomings— a deeply ingrained sense of their own superiority as writers showed in their demands for special treatment and their patronizing and harsh criticism of fellow revolutionaries. In "Ru wu" [Entering the ranks],[40] for example, under the guise of praising the simple, honest soldier, Ding Ling contrives an ill-natured and petty attack on the kind of vacillating intellectuals the party was still trying to win over. In his reply, Mao does not forbid such criticism outright, but confines himself to cautioning writers to choose their targets with an eye to the larger issues and not to attack mistakes made within the revolutionary camp with a ferocity appropriate to the enemy. The ferocity that Mao then extended in practice toward Wang is not hinted at in the reasonable tone of the "Talks," but is nevertheless a widely acknowledged fact. One possible reason for the scapegoating and persecution of Wang above any of the other writers or critics in the Rectification Campaign was suggested at the time (but outside Yan'an) to be an oblique but sharp reference in "Wild Lilies" to the influence of Jiang Qing since her arrival in Yan'an.[41] This may be given credence by the statement attributed to Mao that Wang's

execution during the evacuation of Yan'an in 1947 was not approved
by the Central Committee.

The second main group of arguments raised by the writers
concerned the question of which were the most fundamental: class
or political values, to be determined by the party, or universal
values of humanity, love, spirituality, and so on, more properly
(in their eyes) the responsibility of writers and other intellectuals.
Wang Shiwei, for example, asserted that the task of politicians was
to reform society; that of writers, to reform men's souls.[42] He
further claimed that except for the very top political leaders, most
of the leadership cadres used the revolutionary movement for their
own benefit; writers, on the other hand, who are by nature "more
passionate, more sensitive," approach their fellow men from a feeling
of love and an interest in all aspects of human nature. Writers, he
therefore maintained, should not only be interested in changing the
world, but should also be concerned with universal traits in man's
nature and personality. The general tone of this article, in con-
trast to Wang's earlier cogent criticism, is abstract and theoretical.

Ai Qing's article on the same topic is also general, but even
more vague and at times self-contradictory.[43] On the one hand, he
agreed that the function of art is to promote social reform and pre-
faced his own critical remarks on Yan'an with the description of
writers as loyal soldiers who defend the class or nation to which
they belong, fighting on a spiritual plane. On the other hand, he
quotes with apparent approval the "anti-utilitarian aestheticist"
Théophile Gautier to the effect that art serves the spiritual rather
than the material needs of mankind. Again with apparent approval
he cites unnamed spokesmen for the capitalist and imperialist worlds,
who claim respectively that Valéry's "Cantate du Narcisse" was a
more important event for France than World War I and that
Shakespeare is more important to the British Empire than India.
Having therefore established the importance of literature for na-
tional morale (whether shaking or bolstering it), Ai Qing concludes
that writers are entitled to love and respect from their fellow coun-
trymen. He asks that writers be allowed the freedom to criticize
their surroundings on the grounds that writers put their heart's
blood into their work, and that surgical criticism is beneficial to
social health. The possibility that sincerity or earnestness may not
be sufficient qualification for wielding a surgeon's knife does not
seem to occur to him.

Although Mao does not spend much time contesting this point, it would seem to me that claims by Wang Shiwei and Ai Qing for the moral superiority of writers hardly stand up to scrutiny. Writers are just as venal as any other members of the human race, and their motives are just as mixed as those of politicians and bureaucrats: some have a genuine concern for humanity as a whole, some— even great ones— are highly egotistical and contemptuous of "ordinary" people. Neither politicians nor writers can claim a monopoly on passion, sensitivity, or any other virtue, just as abuses in power-holding or administration should be open to correction by any group or individual in society. This second pair of *zawen*, with their special claims for privilege, are less credible than the first pair (by Wang and Ding Ling). The second pair have been characterized as "literary" in that they refer specifically to writers, but they fail to present a convincing case for the independence of literature, let alone the special problems of writers who are also communist revolutionaries, and are thus easy targets for Mao's satire.

What may have irritated Mao particularly was the accusation of spiritual or moral inadequacy in the party's ideology. Marxism is not a purely mechanistic and materialistic theory for the promotion of economic well-being, but a highly idealistic (in the popular sense) philosophy seeking justice and emancipation for the impoverished, oppressed, and alienated of the world. The Maoist interpretation of Marxism even at this time had a strong tendency toward idealism (in the philosophical sense), and Mao was deeply concerned with the problem of changing human souls: his whole purpose in the Rectification Campaign was to alter people's behavior by influencing their moral and philosophical attitudes, in an attempt to create a new mentality of resistance, self-reliance, self-sacrifice, generosity, and courage.

It is possible that Mao may have distorted or exaggerated for satiric purposes the writers' claims that such things as love and human nature were universal or beyond class interests. Nevertheless, similar claims had been made by left-wing writers at other times, and in the heat of the debate following Mao's introductory remarks, they may have been brought up again. Having lived and fought in a war that had already lasted some fifteen years, Mao was highly impatient with notions of universal humanity and love. His wife, his children, and his brother had been executed by Nationalists, and his comrades had all suffered similar losses; many had already fallen or barely escaped with their lives. The hardships they had

endured were enormous, and the odds against them still great. More recently, their country had been overrun by invaders acting with unprecedented brutality. Mao's satirical disbelief that a revolutionary could talk about universal love at a time like this may not be expressed in a way which is factually or logically justifiable, but in its exaggeration it was a true response to the realities of the time.

An implicit issue in the whole debate was who possessed the stronger claim to legislate on literary matters. Many of the May Fourth writers who came to Yan'an were seasoned revolutionaries as well as writers; not only had they actively pursued the study of Marxist or revolutionary literary theory for a decade or more, but they, too, had suffered deeply for their beliefs, enduring imprisonment, bereavement, and indigence. Writers like Ding Ling came to Yan'an covered in glory, heroes in their own eyes and in the eyes of their readers. As professional writers and revolutionaries too, they could claim precedence over Mao in literary matters: Mao had played no part in the literary revolution of May Fourth and showed little interest in its achievements. As revolutionaries they considered themselves Mao's equals; as writers, they were the exclusive guardians of literary affairs.

Mao refused to accept this ordering of hierarchies. In his poem "Xue" [Snow], written six years earlier, Mao pictured himself as a "heroic character" who surpassed the great founders or empire-builders of former dynasties with his unique mastery over both politics and culture.[44] He had been writing poetry in classical style since at least 1925 and was senior in age and literary experience to the Yan'an writers. Like many of his generation, moreover, he found May Fourth writing thin and insipid when compared to traditional fiction and poetry.[45] The only May Fourth writer he publicly praised was Lu Xun, who was closest to him in age and in style. Mao had managed to overthrow the "foreign experts" in party policy, and was not about to be humbled by Westernized "experts" who claimed a monopoly on literary matters. Armed with the conviction of his own literary ability, and very likely egged on by his wife for her own complicated reasons,[46] he marched into the writers' camp and laid down the rules for its conduct.

Many commentators have noted the apparent gap between Mao's directives on literature and his own practice as a poet. In fact, the gap was not so broad, and private statements made by Mao (some made public only after his death) indicate a possible further narrowing.[47] Mao was a classicist in his attitude toward art; he regarded

art as a skill that can be learned, not as a gift of sensibility or in-
spiration that comes mysteriously to a chosen few. The political
allegiance of an artist determined the political nature of the artistic
product, but its artistic quality was the result of patient and pro-
longed effort. In the world into which Mao was born, writing poetry
was a social accomplishment to which all educated persons aspired.
He was not the only poet among the Yan'an generals: also in the
club were Zhu De, Chen Yi, Dong Biwu, Ye Jianying, and probably
others. The only comparable situation I can think of where warriors
and peasants alike composed poetry in intricate measures is the Iceland
of the Edda and later.[48] Not everyone, of course, wrote poetry,
and the elite in China paid little attention to the efforts of the lower
classes, but the course of Chinese poetry shows the interaction be-
tween these different levels. As Craig points out, "'Poetry' is a
highly mixed entity—it is a term given to different things by dif-
ferent ages and different cultural groups. It can be used to cover
forms of philosophy, propaganda, and prayer, and a host of directly
functional forms that include lullabies, work songs, weather rhymes,
and the bits in the 'In Memoriam' columns of the newspapers."[49] So
in China has poetry been something of the same kind of workhorse.

The May Fourth writers tried to distinguish themselves from
this "amateur accomplishment" tradition, partly by trying to estab-
lish themselves as a professional group whose function as writers
set them off from the rest of society; they had their special status
as writers, and society should respect this status. At the time of
the Yan'an conference, Mao disputed their "special function," al-
though he did not really attack their professional status as he was
to do in the late fifties. He demanded, however, that their profes-
sional concerns (e.g., the raising of cultural standards) not hinder
the revolutionary cause. Throughout the "Talks," he refers to
writers and artists as "workers in literature and art" or "specialists,"
rather than as professionals. He allows that they have special
skills, but in demanding that these skills be shared with the masses,
he deprives them of any exclusive mystique.

Mao's understanding of the nature of poetry may be called
classicist because of its similarities to the Western classicist, as
distinct from modernist, poetics described by Barthes:

> Classical poetry is felt to be merely an orna-
> mental variation of prose, the fruit of an *art* (that
> is, a technique), never a different language, or the

product of a particular sensibility. Any poetry
is then only the decorative equation, whether
allusive or forced, of a possible prose which is
latent, virtually and potentially, in any conceiv-
able manner of experience. 'Poetic', in the days
of classicism, never evokes any particular domain,
any particular depth of feeling, any special co-
herence, or separate universe, but only an indi-
vidual handling of a verbal technique, that of
'expressing oneself' according to rules more
artistic, therefore more sociable, than those of
conversation, in other terms, the technique of
projecting an inner thought, springing fully
armed from the Mind, a speech which is made
more socially acceptable by virtue of the very
conspicuousness of its conventions. . . .
[Modern] Poetry is then no longer a Prose either
ornamental or shorn of liberties. It is a quality
sui generis and without antecedents. It is no
longer an attribute but a substance, and therefore
it can very well renounce signs, since it carries
its own nature within itself, and does not need to
signal its identity outwardly: poetic language and
prosaic language are sufficiently separate to be
able to dispense with the very signs of their dif-
ference. . . . In modern poetics . . . words pro-
duce a kind of formal continuum from which there
gradually emanates an intellectual or emotional
density which would have been impossible without
them; speech is then the solidified time of a more
spiritual gestation, during which 'thought' is pre-
pared, installed little by little by the contingency
of words. . . .[50]

The distinction perceived by Barthes between classical and
modern poetry in French literature may also be seen in Chinese
literature. Confucius comments on poetry thus:

My children, why do you not study the *Songs*?
The *Songs* serve to stimulate the mind, and they
may be used for observation. They teach the art
of sociability, and how to express resentment.
From them you learn the more immediate duty of

> serving one's father, and the remoter one of
> serving one's ruler. From them we become
> largely acquainted with the names of birds,
> beasts and plants.[51]

In these brief sentences, Confucius provides a multifunctional analysis of existing Chinese poetry as a means for enjoyment or entertainment, extension of knowledge or sharpening of perception, social communication, protest, promotion of domestic harmony, service to the ruler, and a mnemonic device or learning aid. There is nothing in this passage by Confucius that might be out of harmony with the fundamental attitudes of the "Talks." Neither Confucius nor Mao allows for the role of the poet as prophet, in mysterious sympathy with the forces of history or the universe (or by extension a flagbearer in the vanguard of the revolution), by virtue of exalted powers of sensitivity or moral judgment. It may well be that these role types entered Chinese literature at a later stage of its development; nevertheless, it still seems that the immense gap in modern Chinese poetry is not between Mao's theory and practice, but between Mao the classicist and the May Fourth moderns.

In the fifth and final section, Mao sums up the debates by putting them into the larger context of the whole rectification movement, his attempt to restructure the political hierarchy and thinking of Yan'an party members, intellectuals, and officials. His summary includes one very important literary point foreshadowed in the earlier discussion. In a passage relating to the writer's attitude toward his audience, Mao talked at some length about the dialectical materialist view of the relation between motive, or subjective desires, and effect, or social practice; his conclusion was that in judging a writer's work, we should not accept without question the motives professed by the writer, but should rather be guided by the effect of his work on social practice. The widespread tendency to take as infallible a writer's comments on his own work, labelled by some Western literary theorists as the "intentional fallacy," has been discredited as a method in literary criticism.[52] No matter what the intentions of a writer when he or she starts to write, and no matter how sincere these intentions may be, the process of writing itself, of creating a work of art, involves more than the conscious mind itself and affects the original intention, so that the end product may produce an effect quite contrary to the author's expectations or understanding. The need for such a concept in modern Chinese literature is very clear. Yu Dafu, for instance, was fond of saying

that "all literature is autobiography," and apparently was not averse to the notoriety that his explorations into more or less abnormal sexuality (masturbation, homosexuality, foot-fetishism, masochism, etc.) therefore drew; yet, as has been convincingly pointed out, the very versatility of Yu's protagonists precludes their autobiographical authenticity.[53] A similar example can be found in Lu Xun's oft-stated purpose in writing, namely, to disturb the apathy of the Chinese and to transform their spectator mentality into rebelliousness. In effect, however, the propaganda value of Lu Xun's fiction is debatable, whereas its artistic value is universally recognized.

The problem of authorial intentions in literary creation was certainly known to Marx and Engels. The *locus classicus,* frequently cited in Soviet literary criticism, is the passage by Engels on the historical value of Balzac's descriptions of the last remnants of aristocratic society in eighteenth-century France. In his own political beliefs, Balzac was a professed legitimist, but as Engels points out in admiration, "his satire is never keener, his irony never more bitter" than when it is directed against "the people with whom he sympathises most deeply— the nobles." In what Engels calls "one of the greatest triumphs of realism," Balzac in his novels therefore goes against his own class sympathies and political beliefs.[54] This example of contradiction between motive and effect was also quoted in Chinese literary criticism in the fifties. Mao's own discussion on motive and effect is clear and persuasive; however, it conflicts with the earlier passages from section three of the Conclusion in which Mao insists that art always follows politics, and in a class society, serves its own class. In practice, Mao would seem to follow his more liberal line, so that he can admit the value of literature produced by the feudal class which criticizes and undermines the basic beliefs of that class.

The example of intentional fallacy given by Mao in the concluding passage of the "Talks" is in fact a kind of mirror image to the Balzac example. Mao points out that Fadeyev's *Razgrom* [The nineteen] sets out to describe a small and socially very humble group of people, common soldiers, in a very narrow and specific setting, the revolutionary struggles of 1917; in addition, the author's motive was consciously political, to serve immediate political ends. Nevertheless, the novel itself proved in practice to have widespread appeal and was highly acclaimed as a work of art. This was hardly a message that May Fourth writers needed spelled out, since a prominent feature of the May Fourth literary movement was the

recognition that writers from poor and oppressed countries writing about their own backward people had created or were creating authentic national literatures deserving an honored place in world literature. It does, however, serve as a valuable reminder to writers and literary critics that the relationship between literature and politics is a complex one, and not necessarily one of irreconcilable conflicts.

Finally, a few words should be said about the effects of Mao's Yan'an "Talks." The most immediate and striking consequence was the silencing of the May Fourth writers in Yan'an, to be followed by the denial of the May Fourth tradition in China after 1949 (apart from brief periods of respite), and such personal tragedies as the purge of Ding Ling and the suicide of Lao She. But in terms of literature there is also a more positive effect that should be noted. Although the attention of left-wing writers was drawn to folk culture as early as the thirties,[55] there was not only strong (if unexpressed) resistance to it on the part of professional writers, but also a tendency among party cadres to dismiss some of the most popular forms as too backward. In the immediate aftermath of the "Talks," however, a new interest in popular literature and the theater was cultivated, and such forms as the *yangge* ("rice-sprout song," a combined dance and dramatic performance) and *kuaiban* ("quicksticks," a chanted narrative with castenet accompaniment) were adapted for political education. Among the foremost achievements of Yan'an literature and art were *Bai mao nü* [White-haired girl], based on *yangge* tunes, Zhao Shuli's *Li Yucai banhua* [Rhymes of Li Yucai], incorporating traditional narrative techniques and ballads, and Li Ji's *Wang Gui yu Li Xiangxiang* [Wang Gui and Li Xiangxiang], based on a local couplet form.

After 1950, Mao's "Talks" were used to justify renewed attention to China's classical tradition, and adaptations of folk literature to modern needs seemed to become less important. There seemed to be a revival of May Fourth modes, particularly in fiction. Ding Ling and Ai Wu were writing and publishing again, old May Fourth literature was reprinted and translated, and Zhou Erfu's *Shanghaide zaochen* [Morning in Shanghai] and Yang Mo's *Qingchunzhi ge* [Song of youth] appear as more tendentious sequels to Mao Dun's *Ziye* [Midnight] and Ba Jin's sentimental novels of revolutionary youth in the May Fourth period. According to Joe C. Huang, the most successful novels of the fifties and sixties were those owing most to traditional styles, but the use of these techniques does not

seem to have formed a major issue in discussions on literature.[56] In poetry, the dominant May Fourth mode of free verse retained its position, and in the theater the *huaju* (Western-style "spoken plays") was the major vehicle for new writing.

During these years, Mao's "Talks" was far from dominating the literary scene. Though it remained in service as official policy, the frequency of its citation declined markedly during the fifties. In *Chinese Literature*, for instance, under the editorship of Mao Dun, the debates on the relaxation of literary policy in 1957 barely mention Mao by name at all, and the "Talks" are not cited or referred to anywhere. (The "hundred flowers" directive is described only as "issued by the Central Committee.") In the final issue for 1957, there are three short articles in honor of the fifteenth anniversary of the "Talks," but no major article or glowing editorial. The anniversary was observed with more attention in *Wenyi bao* and other Chinese-language journals, but otherwise the "Talks" was not much emphasized. The sudden release of the first batch of Mao's poems in 1957 can be seen as an attempt by Mao to reassert his claim for literary leadership.[57] It was followed in 1958 by the Mao-backed "poetry campaign," which, despite official support from Zhou Yang and Guo Moruo, can be seen as an attempt to undermine the monopoly on literature still exercised by the May Fourth old guard of professionals. In 1959 Zhou Yang struck out with the slogan "literature for the whole people," and in the early sixties even announced that literature need not always be political in content.[58] Unfortunately for Zhou, his attempt to alter policy in accordance with the spirit of the "Talks" was seized upon at the beginning of the Cultural Revolution as evidence of a deliberate betrayal of principles.

It was not until the Cultural Revolution that the "Talks" resumed its former prominence. On 1 July 1966, *Hongqi* [Red flag] reprinted the "Talks" in full, along with an editorial attacking Zhou Yang, and on 23 May 1967, the twenty-fifth anniversary of the "Talks," *Renmin ribao* [People's daily] also reprinted the "Talks." During the Cultural Revolution, most journals suspended publication, so that from mid-1966 to 1972 the only cultural magazine in publication was *Chinese Literature*. In October 1966, August 1967, and May 1972, when special celebrations were held throughout the country, *Chinese Literature* reprinted the "Talks" in full, which it had never done in the fifties and sixties.[59] *Wenwu*, which had steadfastly ignored the "Talks" throughout the fifties and early sixties (and which had just resumed publication in 1972), also marked the latter

occasion with several articles on the history, bibliography, and general impact of the "Talks."

Along with new emphasis on the "Talks" and the overthrow of the old Ministry of Culture under Mao Dun and Zhou Yang, Chinese writing over the last half-century was denounced as worthless (the only authors excepted from censure were Lu Xun, Hao Ran, and Mao himself). On the positive side, the major effect of the reversion to the principles of the "Talks" was the production of new scripts for Peking opera with workers, peasants, and soldiers as protagonists. These new scripts began to appear a few years before the Cultural Revolution and dominated the Chinese cultural scene up to 1976. Peking opera is one of the most stylized art forms of late traditional Chinese society, and simultaneously one of the most genuinely popular. The reforms instituted under the direction of Jiang Qing (whose role is now disputed) introduce Western music into the score and eliminate such anomalies as males in female roles, but many of the old conventions have been skillfully adapted to meet the needs of new stories and characters. In the countryside, illiteracy still narrowed the audience for novels and other forms of written literature, so that publication figures for even the most popular novels of the sixties only reached a few million in a population of six or seven hundred million.[60] Beginning around 1970, many of the new operas were "transplanted" into regional forms, and new regional operas were encouraged in a further effort to reach wider audiences by using a familiar stylistic vocabulary. In the novel, Hao Ran was experimenting with a more traditional vocabulary and method, though the general short story writing of the seventies was so bland as to be difficult to categorize. In poetry, there was a minor revival of both classical and folk styles, and the nature of "new poetry" was once again a matter for debate. Both before and after Mao's death, and with his direct encouragement, more emphasis was placed on the need for the "new poetry" to base itself on traditional and classical forms. Some of the publicity given to classical poetry is directly political, a desire to enhance the prestige of the old guard leadership; what remains significant is the continued prestige that classical poetry obtains among the elderly and not so elderly revolutionaries.

The further cultural liberalization that took place between 1976 and 1979 consisted first of the reissue of literature from before the Cultural Revolution, together with some May Fourth literature, traditional literature, and selected foreign (mainly Western) literature,

and later (1978-79) of the production of literary works highly criti-
cal of the immediate past, for publication in both official and non-
official media. It is too early to comment on the future of this "new
wave" in Chinese literature, but in spite of the deep hostility now
felt toward Mao and his policies, the influence of his "Talks" can
still be discerned.

As expounded in the "Talks," Mao's views on the origins and
use of literature are limited and overly simple for general use, but
nonetheless valid and rational in regard both to the circumstances
of war and revolution in which the "Talks" were given and to the
nature of their audience of self-proclaimed revolutionary writers—
those new arrivals from Shanghai with all their cliques and unsavory
scandals. The "Talks" are broad enough to be put to many uses,
including misinterpretation by selective quotation. While the practi-
cal effects of Mao's "Talks" are dependent upon the general policy
line at any given time, they also contain justification for the opposi-
tion to overturn policy when the political opportunity is there. For
a reader not obliged to follow any exclusivist interpretation, the
"Talks" remains useful as a historical document for elucidating works
from their specific historical period and location, as a guide for
general left-wing literary analysis, and as a model for literary policy
in a revolutionary period. Nevertheless, we should keep in mind
that the periods of greatest circulation of the "Talks" have coin-
cided with the most intense censorship and persecution of individual
writers. It would be a great pity if the Maoist injunction to use the
past to serve the present found its chief example in a harsher sup-
pression of popular culture than even the literary inquisitions of
Yuan, Ming, and Qing.

NOTES

1. Translated by James R. Lawler, in *The Collected Works of Paul Valéry*, ed. Jackson Mathews (London, 1971), 1:397.

2. Subsequently published as *Communist Chinese Literature*, ed. Cyril Birch (New York, 1963).

3. Douwe W. Fokkema, *Literary Doctrine in China and Soviet Influence, 1956-1960* (The Hague, 1965), p. 19. The statement is conditional and impersonal, but seems to sum up Fokkema's attitude.

4. T. A. Hsia, "Twenty Years After the Yenan Forum," *China Quarterly*, no. 13 (January-March 1963), pp. 226-53, esp. p. 246.

5. Ernst Fischer, *The Necessity of Art: A Marxist Approach*, trans. Anna Bostock (Harmondsworth, 1963), p. 205.

6. See Terry Eagleton, *Criticism and Ideology: A Study of Marxist Literary Theory* (London, 1976), and *Marxism and Literary Criticism* (Berkeley and Los Angeles, 1976); David Craig, *The Real Foundations: Literature and Social Change* (London, 1973), esp. pp. 229, 286-87, and Craig, ed., *Marxists on Literature: An Anthology* (Harmondsworth, 1975); Raymond Williams, *Culture and Society* (London, 1958), and *Marxism and Literature* (London, 1977), esp. pp. 202-3; Maynard Solomon, comp., *Marxism and Art: Essays Classic and Contemporary* (New York, 1973), esp. pp. 250-52; Ernst Fischer, *The Necessity of Art* (Harmondsworth, 1963). In *Real Foundations*, Craig only refers to Mao as a political leader, but praises Lu Xun at length; in his *Marxists on Literature*, he quotes a crucial passage from the "Talks" in his introduction (p. 14), and includes two Lu Xun essays in the body of the anthology. Craig's selections (e.g., those by Thomson, Kettle, Craig,

Adereth, and Fischer) tend to deal with the same kinds of
problems as raised in the "Talks." I am much indebted to John
Schrecker for discussion on these issues. The Solomon anthol-
ogy contains one selection from the "Talks," on political and
artistic criteria in criticism. For a non-Marxist perspective,
see Jürgen Rühle, *Literature and Revolution: A Critical Study
of the Writer and Communism in the Twentieth Century* (London,
1969), pp. 411-15. Written without firsthand knowledge of the
Chinese literary scene, Rühle's account is inaccurate in many
details; for example, Chinese writers were employing the ver-
nacular long before Mao's "Talks," and Mao's poetry is neither
"idyllic" nor "bourgeois." Rühle claims that Mao, as a "poet
and thinker," "a star of the first magnitude," is able to "wipe
out all the crimes which the dictator by that same name has
committed against the human achievements of past milleniums"
(pp. 413-14); personally, I find this judgment both ill-founded
and perverse.

7. Cyril Birch, "The Particle of Art," *China Quarterly,* no. 13
(January-March 1963), pp. 3-14, esp. pp. 4-5.

8. Ibid., p. 8.

9. Ibid.

10. Apart from the *China Quarterly* articles mentioned above and
C. T. Hsia's *A History of Modern Chinese Fiction* (New Haven,
1971), very little has been published on Chinese literature since
1942. The most interesting general account is Joe C. Huang's
Heroes and Villains in Communist China (New York, 1973).
However, this work suffers from the same methodological weak-
ness as his predecessors' work, although his attitudes toward
the literature are much more favorable. Cyril Birch's pioneer-
ing work begins with "Fiction of the Yenan Period," *China
Quarterly,* no. 4 (October-December 1960), pp. 1-11, and con-
tinues in "Change and Continuity in Chinese Fiction," in
Modern Chinese Literature in the May Fourth Era, ed. Merle
Goldman (Cambridge, Mass., 1977), pp. 385-404. A promising
line of research is indicated in David Holm's "Introduction to
Ma Ke's 'Man and Wife Learn to Read'," in *Revolutionary Litera-
ture in China: An Anthology,* ed. John Berninghausen and
Ted Huters (White Plains, N.Y., 1976), pp. 71-73.

11. For further details on different versions, see Appendix 2.

12. For further details on translations, see Appendix 3.

13. For a complete list of all revisions that survive translation, see Appendix 1.

14. In one passage in the Introduction, Mao uses the expression "workers, peasants, and soldiers" *(gong nong bing)* four times and the expression "workers and peasants" *(gongren he nongmin)* once. In the revised version, this is changed to "workers and peasants" four times and "workers, peasants, and fighters in a revolutionary army" *(gongren, nongmin, he gemingjunde zhanshi).* This may itself point to a de-emphasis on the military, but as the only instance of such a change, it should perhaps not be seen as significant.

15. See Paul G. Pickowicz, "Qu Qiubai's Critique of the May Fourth Generation: Early Chinese Marxist Literary Criticism," in Goldman, *Modern Chinese Literature,* pp. 351-84, and "Ch'ü Ch'iu-pai and the Marxist Conception of Revolutionary Literature and Art," *China Quarterly,* no. 70 (June 1977), pp. 296-314; and C. T. Hsia, *History of Modern ·Chinese Fiction,* pp. 311-12.

16. The influence of Lu Xun on Mao's "Talks" is claimed by Victor Nee and James Peck in "Introduction: Why Uninterrupted Revolution?" in *China's Uninterrupted Revolution, From 1840 to the Present,* ed. Victor Nee and James Peck (New York, 1975), pp. 40-42; and by Jean Charbonnier, "Mao Tse-tung et Lu Hsun," *France-Asie,* no. 4 (1974), pp. 7-28. Although the precise nature of such an influence has yet to be established, Lu Xun is still the only May Fourth writer praised by name in Mao's published work.

17. Only a few eyewitness accounts of the Yan'an Conference have come down to us, and these are all from a party point of view; e.g., Liu Xuewei, *Lun wenxuede gongnongbing fangxiang* [On the worker-peasant-soldier direction in literature] (Shanghai, 1949), cited in T. A. Hsia, "Twenty Years after the Yenan Forum," p. 226; Ma Ke, "Yan'an Luyi shenghuo zayi" [Recollections of life at the Lu Xun Academy of Literature and Art in Yan'an], *Hong qi piaopiao* [The red flag flutters],

no. 16 (October 1961), pp. 148-66; and (possibly) Qin
Yansheng, "'Zai Yan'an wenyi zuotanhuishangde jianghua'
fabiao qianhou wenyijiede yixie qingkuang jian" [A brief intro-
duction to some conditions in literary and art circles before
and after the publication of "Talks at the Yan'an Conference
on Literature and Art"], *Wen wu* [Cultural relics], May 1972,
pp. 3-8. Ma Ke's account differs notably from the accepted
version when he mentions only one speech by Mao and gives
its date as 30 May; I have no explanation for this discrepancy.
Another account, sympathetic to Wang Shiwei but not an eye-
witness, also seems at variance with the official record: see
Ji Yu, "'Ye baihehua' de qianqian houhou" [Events surrounding
"Wild Lilies"], preface to Wang Shiwei, *Ye baihehau* (Chungking,
June 1942), section 1, pp. 1-11. *Jiefang ribao* at the time
was reticent to the point of secrecy about the conference meet-
ings and yields little concrete information on dates, participants,
etc. Zhou Libo's "Twenty Years Ago," *Peking Review* 5, no.
22 (1 June 1962): 18-19, describes the first meeting as opened
by Zhu De and addressed by Mao. Xiao Jun's "Duiyu dangqian
wenyi zhu wentide wo jian" [My views on current questions on
literature and art], *Jiefang ribao*, 14 May 1942, p. 4, mentions
two speakers, Mao and [He] Kaifeng; Qiu Shui mentions the same
pair in his "'Ye baihehua an' guan zhan ji" [Notes on the battle
of ideas in the "Wild Lilies" case], in Wang, *Ye baihehua*, sec-
tion 3, pp. 1-9, esp. p. 4.

18. Reception studies, for instance, are given only brief mention
in René Wellek and Austin Warren, *Theory of Literature* (New
York, 1949); no additions either to text or to bibliography appear
in the revised version of 1956. Two early studies are Ashley
H. Thorndike, *Literature in a Changing Age* (New York, 1920),
pp. 21-46, and Q. D. Leavis, *Fiction and the Reading Public*
(London, 1932), followed by Richard D. Altick, *The English
Common Reader: A Social History of the Mass Reading Public,
1800-1900* (Chicago, 1957) and Richard Hoggart, *The Uses of
Literacy* (London, 1957); see also Hoggart's essays in his
Speaking to Each Other, 2 vols. (New York, 1970), especially
1:114-30, 2:19-39, 246-59. The definitive demonstration of the
close relationship between rhetoric and reader expectation is
Wayne C. Booth, *The Rhetoric of Fiction* (Chicago, 1961).

19. Eagleton, *Marxism and Literary Criticism*, pp. 2-3. A reso-
lutely non-Marxist example is *The Sociology of Literature*,

Diana Laurenson and Alan Swingewood (London, 1972): its sur-
vey of the rise and theory of the sociology of literature is par-
ticularly ill-informed on Marx and Lenin (chap. 3), while the
section on the writer and society has interesting information
but is weak on theory and coherence. Of the two Marxist an-
thologies cited in note 6 above, Craig has some examples of this
kind of criticism (Kettle), but Solomon tends to ignore it. Inso-
far as oral or "primitive" literature is mentioned, e.g., by George
Thomson, *Studies in Ancient Greek Society: The Prehistoric
Aegean* (London, 1954) (see excerpts in Craig, ed., *Marxists
on Literature*, pp. 47-75 and Solomon, comp., *Marxism and
Art*, pp. 342-54), the attitude is patronizing, and contemporary
popular culture is ignored. Thomson's account of the composi-
tion of oral poetry (*Marxism and Art*, pp. 347-54) is extremely
dubious, especially in light of recent research, e.g., Albert
B. Lord, *The Singer of Tales* (Cambridge, Mass., 1960).

20. See Marx, excerpt from "Introduction to the Critique of Politi-
cal Economy," and Engels, excerpt from "The Housing Question,"
in *Marx and Engels on Literature and Art: A Selection of Writ-
ings*, ed. Lee Baxandall and Stefan Morawski (St. Louis, 1973),
pp. 134-36, 72-73. Other passages give a different impression:
their "Manifesto of the Communist Party," Marx, excerpt from
The Eighteenth Brumaire of Louis Bonaparte, and Engels, ex-
cerpt from *The Condition of the Working Class in England in
1844*, in Karl Marx and Friedrich Engels, *Literature and Art*
(New York, 1947), pp. 72, 97-98, 115-16.

21. Williams, *Marxism and Literature*, p. 52. For an exhaustive
survey of Marx's literary tastes, see S. S. Prawer, *Karl Marx
and World Literature* (Oxford, 1976). According to Prawer,
Marx was aware of differences in audience levels, but assumes
that literature for a popular and uneducated audience requires
simplicity in language and structure (pp. 258, 280-86).
Prawer's book contains the most careful and thorough analysis
of Marx's views on literature and art; see especially the chap-
ter "Models and Metaphors," pp. 272-306.

22. See V. I. Lenin, "Party Organization and Party Literature"
and "On Proletarian Culture," in C. Vaughan James, *Soviet
Socialist Realism: Origins and Theory* (New York, 1973), pp.
102-6, 112-13; see also the discussion by James in chaps. 1
and 2.

23. Qu Qiubai, "'Women' shi shui?" [Who are "we"?], in *Qu Qiubai wenji* [Collected works of Qu Qiubai], 4 vols. (Peking, 1953-54), 2:875-78, trans. Paul G. Pickowicz, in *Revolutionary Literature in China*, ed. John Berninghausen and Ted Huters, pp. 44-46, and "Ouhua wenyi" [Europeanized literature and art], 2:879-94; Guo Moruo, "Geming yu wenxue" [Revolution and literature], in *Moruo wenji* [Collected works of Guo Moruo], 17 vols. (Peking, 1957-63), 10:312-23, trans. Lars Ellström, in *Revolutionary Literature in China*, pp. 27-32.

24. Wayne C. Booth, *The Rhetoric of Fiction*, p. 396.

25. Stuart R. Schram, *The Political Thought of Mao Tse-tung* (Harmondsworth, 1969), pp. 360-61.

26. See James, *Soviet Socialist Realism*, p. 86. For the use of the term "proletarian realism" in China and Japan in the twenties and thirties, see Marián Gálik, "Studies in Modern Chinese Literary Criticism: III. Ch'ien Hsing-ts'un and the Theory of Proletariat Realism," *Asian and African Studies*, no. 5 (1969), pp. 49-70. He Qifang, commenting on the original text in 1951, explains the use of the term "proletarian realism" as a deliberate reference by Mao to the fact that a socialist society did not at that time exist in China; see his "Yong Mao Zedongde wenyi lilun lai gaijin womende gongzuo" [Improve our work by means of Mao Zedong's theories on literature and art], *Wenyi bao*, January 1952, pp. 5-9. On the basis of linguistic analysis of the text, Jerome Chen surmises that portions of the original text were written by one or more other people, possibly Jiang Qing, Zhou Yang, or Chen Boda; see his *Mao Papers: Anthology and Bibliography* (London, 1970), pp. xxvii-xxviii. Were this the case, even if Mao himself had slipped, one might have expected his "collaborators" to have picked up the error.

27. It is not clear what Mao had read by this time of Soviet literary criticism. Much was already translated into Chinese by the mid-thirties, e.g., Lu Xun's translation of A. V. Lunacharsky and G. V. Plekhanov. *Problems of Soviet Literature: Reports and Speeches at the First Soviet Writers' Congress* (English trans., Moscow, 1935), which contained speeches by Zhdanov, Gorky, Bukharin, etc., refers twice to the combination of revolutionary romanticism and socialist realism in Soviet literature (pp. 21-22, 253), but neither of these two terms appears

in the original text of the "Talks." Gorky's work on compiling factory histories (pp. 68-69) was mentioned in the "Talks," but Mao's knowledge could easily have come from a different source.

28. See Harold Swayze, *Political Control of Literature in the USSR* (Cambridge, Mass., 1962), pp. 54-56.

29. See, for instance, Altick, *The English Common Reader*, pp. 240-59.

30. The texts containing the scattered remarks by Marx and Engels on literature and art were first collected in Russian in 1933, with German and English versions appearing in 1937 and 1947 respectively. The latter was the basis for the 1949 American collection *Literature and Art*, mentioned in note 14 above. Since then more material has become available, as in the 1973 *Marx and Engels on Literature and Art* (note 14 above). Mao was presumably aware of more well-known pieces, such as *A Contribution to the Critique of Political Economy* with its oft-cited prefatorial remarks on the relation of the superstructure to the economic basis, but he may not have known the fragmentary and posthumously published "Introduction to the Critique of Political Economy" with its equally important qualifications to the relationship, especially in regard to literature.

31. See Baxandall and Morawski, eds., *Marx and Engels*, p. 85. For a survey of Russian theories of Marxist aesthetics based on this premise, see Edward J. Brown, *Russian Literature Since the Revolution* (London, 1969), pp. 194-230. A notable exponent in the West was Christopher Caudwell in his *Illusion and Reality* (London, 1937), esp. p. 11; and *Studies and Further Studies in a Dying Culture* (London, 1938 and 1949; in one volume, New York, 1971). A new approach in contemporary Marxist criticism is to consider the effects of economic and social conditions on literary form, e.g., Raymond Southall, *Literature and the Rise of Capitalism: Critical Essays Mainly on the Sixteenth and Seventeenth Centuries* (London, 1973). See also Eagleton, *Criticism and Ideology:* "In English literary culture of the past century, the ideological basis of organic form is peculiarly visible. . . ." (p. 161) In his dislike for the emergent influence of capitalism, and by failing to delineate the different cultural traditions of the past, Southall implies an idyllic view of feudal ruling culture. Caudwell and Eagleton also assume

a unitary ruling class culture that must somehow be salvaged for the new era of socialism.

32. Baxandall and Morawski, eds., *Marx and Engels*, pp. 134-36. Soviet Russian theorists were familiar with this reservation; see James, *Soviet Socialist Realism*, p. 10. According to Gálik, it was probably this passage that caused Guo Moruo in the late twenties to abandon the idea of "proletarian criticism"; see Gálik, "Studies in Modern Chinese Literary Criticism: IV. The Proletarian Criticism of Kuo Mo-jo," *Asian and African Studies*, no. 6 (1970), pp. 145-60. For a general account of the problems raised by this passage, see Peter Demetz, *Marx, Engels and the Poets: Origins of Marxist Literary Criticism* (Chicago, 1967), pp. 67-73.

33. Engels, excerpts from "Letter to Paul Ernst, June 5, 1890," "Letter to Minna Kautsky, November 26, 1885," and "Letter to Margaret Harkness, Beginning of April, 1888 (Draft)" in *Marx and Engels*, ed. Baxandall and Morawski, pp. 87, 112-13, 114-16.

34. See Lenin, "Party Organization and Party Literature," in James, *Soviet Socialist Realism*, pp. 12-13, 15-16 *et passim*; Solomon, *Marxism and Art*, pp. 180-87, 187-88, 237-38; Eagleton, *Marxism and Literary Criticism*, pp. 40-42; and Fokkema, *Literary Doctrine*, pp. 8-9.

35. Solomon, *Marxism and Art*, pp. 187-88, 237-38, and Eagleton, *Marxism and Literary Criticism*, p. 43.

36. See Nikita S. Krushchev, "For Close Links Between Literature and the Life of the People," in *The Great Mission of Literature and Art* (Moscow, 1964), pp. 12-48, esp. p. 19.

37. See Liu Xuewei as quoted in T. A. Hsia, "Twenty Years after the Yenan Forum," p. 228.

38. See Demetz, *Marx, Engels and the Poets*, pp. 127-29; cf. Prawer, *Karl Marx and World Literature*, pp. 410-11.

39. These two essays were first published in the literary page of *Jiefang ribao*, 9 March 1942, 13 and 23 March 1942, p. 4. See also Goldman, *Literary Dissent*, pp. 23-24, 25-26, and Fokkema, *Literary Doctrine*, pp. 12, 15-16. For translation and

commentary, see Gregor Benton, "The Yenan Literary Opposi-
tion," *New Left Review,* no. 92 (July-August 1975), pp. 93-96.

40. Also translated as "The Soldier and the Journalist"; trans. G.
Begley, *Life and Letters* 60, no. 137 (January 1949): 75-80.

41. See Qiu Shui, "'Ye baihehua an' guan zhan ji," p. 1. For Mao's
admission on the execution of Wang Shiwei, see *Mao Zedong
sixiang wansui* [Long live Mao Zedong thought] (n.p., 1969),
p. 409; trans. John Chinnery and Tieyun in *Mao Tse-tung
Unrehearsed; Talks and Letters, 1956-71,* ed. Stuart Schram
(London, 1974), pp. 184-85.

42. Wang Shiwei's article "Zhengzhijia, yishujia" [Politicians and
artists] is not available in full. Excerpts are quoted in Jin
Canran, "Du Shiwei tongshide 'Zhengzhijia, yishujia' hou"
[After reading comrade Shiwei's "Politicians and Artists"],
Jiefang ribao, 26 May 1942, p. 4, and Qiu Shui, "'Ye baihehua
an' guan zhan ji," pp. 1-9. See also Goldman, *Literary Dissent,*
pp. 26-27.

43. Ai Qing, "Liaojie zuojia, zunzhong zuojia" [Understand and
respect writers], *Jiefang ribao,* 11 March 1942, p. 4. See
also Goldman, *Literary Dissent,* pp. 29-30, and Fokkema, *Lit-
erary Doctrine,* pp. 13-15. Ai Qing may have got his Valéry
poems mixed up, since "Cantate du Narcisse" (Ai Qing's "Shui-
xian ci"?) was only composed in 1939 and was not generally
known to the public until 1941, and other poems with the
Narcissus theme were not major works. He Qifang cites in a
similar context Valéry's "La Jeune Parque"; see his *Xinghuo
ji* [Sparks] (Shanghai, 1949), p. 8. If it is indeed "La Jeune
Parque" to which Ai Qing refers, a poem which Valéry described
as intentionally obscure, written as a way of cutting himself off
from a "world gone mad" (i.e., World War I), it is possible that
Ai Qing had not actually read it but had accepted without ques-
tion the judgment of an anonymous French critic.

44. In *Nineteen Poems* (Peking, 1958), the first English-language
book publication of Mao's poems, with notes by Zhou Zhenfu and
an appreciation by Zang Kejia, the date of "Snow" is given as
1945, that is, the date when it first appeared in Chongqing
The discussion of "Snow" in Ng Yong-sang's "The Poetry of
Mao Tse-tung," *China Quarterly,* no. 13 (January-March 1963),

pp. 60-73, takes 1945 as the date of composition. The early
Chinese editions of the poems do not give any date to "Snow"
at all. Later commentaries, however, generally explain that
the poem was originally composed during the first winter after
Mao's arrival in the northwest; see *Mao Zhuxi shici jiangjue*
[Interpretations of Chairman Mao's poems], interpretations by
Zang Kejia and commentary by Zhou Zhenfu (Peking, 1962,
third ed.), pp. 32-33; [Zhou] Zhenfu, *Mao Zhuxi shici jianshi*
[Commentary and interpretation of Chairman Mao's poems]
(Shanghai, 1961), pp. 76-77; and Zhang Xiangtian, *Mao Zhuxi
shici jianzhu* [Commentary on Chairman Mao's poems], 4 vols.
(Hong Kong, 1969), 2:131-40. All editions of the poems since
1963 give the date of the poem as February 1936. Zhang's very
elaborate commentary explains that the poem can be seen as a
Marxist interpretation of history; former rulers could excel at
wu or military achievements, but were unable to establish *wen*
or civilian rule to maintain good order throughout the country;
only the proletariat possesses true consciousness and is there-
fore able to achieve a true harmony of *wen* and *wu*. The poem
is written with great skill and allows many levels of interpreta-
tion. For a list of translations of Mao's poems, see Appendix 3.

45. See his remarks on poetry in "Zai Chengdu huiyishangde jiang-
hua" [Talks at the Chengdu conference], in *Mao Zedong sixiang
wansui*, p. 180, trans. John Chinnery and Tieyun, in Schram,
ed., *Mao Tse-tung Unrehearsed*, p. 123; and Mao's letter to
Chen Yi on poetry (written 1965), *Renmin ribao* [People's
daily], 31 December 1977, p. 1, translation in *Peking Review*
21, no. 2 (13 January 1978): 6-7. I have discussed Mao's
attitude to various levels of poetry in my "Poems, Poets, and
Poetry 1976: An Exercise in the Typology of Modern Chinese
Literature," *Contemporary China* 2, no. 4 (Winter 1978):
76-124, esp. pp. 96-97.

46. See Qiu Shui, "'Ye baihehua an' guan zhan ji," p. 1.

47. See note 45 above.

48. For a fictional representation of the Eddic tradition surviving
in modern Iceland, see Haldor Laxness, *Independent People*
(New York, 1946).

49. Craig, ed., *Marxists on Literature*, p. 152.

50. Roland Barthes, *Writing Degree Zero*, trans. Annette Lavers and Colin Smith (London, 1967), pp. 48-49.

51. From *Analects*, book 17, chap. 9, in *The Chinese Classics* trans. James Legge, 5 vols. (Hong Kong, 1960), 1:323 (slightly adapted).

52. See W. K. Wimsatt and Monroe C. Beardsley, "The Intentional Fallacy," in Wimsatt, *The Verbal Icon* (Lexington, Kentucky, 1954), pp. 3-18. The companion essay, "The Affective Fallacy," pp. 21-29 (also by Wimsatt and Beardsley), an attack on the subjectivist location of the "aesthetic experience" in the mind of the individual reader or writer, implies the irrelevance of reception studies as well. A radical critique of the New Criticism in America in the postwar period (the movement that launched these two slogans into common usage in the universities) has been made by Richard Ohmann, *English in America: A Radical View of the Profession* (New York, 1976), esp. pp. 66-91.

53. Michael Egan, "Yu Dafu and the Transition to Modern Chinese Literature," in Goldman, *Modern Chinese Literature*, pp. 309-24.

54. Engels, "Letter to Margaret Harkness," and Marx, excerpt from "The English Middle Class," in *Marx and Engels,* ed. Baxandall and Morawski, pp. 114-16, 105. Schwartz points out that since Balzac was not a Marxist himself and had no conscious mission to defend his "class," his criticism of the nobility should not be seen as a contradiction between motive and effect. Mistaken or not, Engels's interpretation has been of great importance in the practice of Marxist aesthetics, allowing a great deal of nonsocialist or nonproletarian literature to slip past the doctrinaires. It should be stressed again that both Marx and Engels has broad and highly developed literary tastes, which were never subjugated to rigid class analysis regardless of possible inconsistency.

55. Ting Yi [Ye Dingyi], *A Short History of Modern Chinese Literature* (Peking, 1959), pp. 44-48.

56. Huang, *Heroes and Villains*, p. 324.

57. See also my "Poems, Poets, and Poetry 1976", pp. 79-80.

58. See, for instance, Li Fan, "Ping Zhou Yangde 'quanmin wenyi'" [Criticize Zhou Yang's "literature for the whole people"], *Renmin ribao*, 30 August 1967, pp. 4, 6. The need for new literary policies was openly discussed in 1962 on the twentieth anniversary of the "Talks," following the editorial in *Renmin ribao* on 23 May 1962; see translations in *Current Background*, no. 685 (3 July 1962).

59. *Chinese Literature* provides an insight into the overt reference to Mao in Chinese cultural life from the fifties through to the fall of the "Gang of Four." From 1951 to 1965, it carried five items (articles or poetry selections) by Mao and eight items (articles or announcements) about him. From 1966 through 1976, there are eighteen items by Mao and seventy-seven about him. I am most grateful to Donald A. Gibbs as editor of *Subject and Author Index to Chinese Literature Monthly (1951-1976)* (New Haven, 1978), esp. pp. 83-86, without which I would hardly have attempted this calculation.

60. Huang, *Heroes and Villians*, pp. 134n, 72, *et passim*.

"Talks at the Yan'an Conference on Literature and Art"*

Mao Zedong

* *Translator's note:* I have retained the original number of sentences from Mao's text. Punctuation within sentences, however, has been changed to conform to standard American usage.

October 19 is the seventh anniversary of the
death of Lu Xun. We have specially published
Comrade Mao Zedong's talks at the Yan'an con-
ference on literature and art to commemorate
the greatest and most heroic standard-bearer
of the Chinese cultural revolution.

People's Daily editor, 1943

INTRODUCTION*

(2 May 1942)

Comrades! I have invited you to this conference today for
the purpose of exchanging opinions with you on the correct relation-
ship[1] between work in literature and art and revolutionary work in
general, to obtain the correct development of revolutionary literature
and art and better assistance from them in our other revolutionary
work, so that we may overthrow our national enemy and accomplish
our task of national liberation.[2]

There are a number of different fronts in our struggle for the
national liberation of China, civil and military, or, we might say,
there is a cultural as well as an armed front. Victory over the enemy
depends primarily on armies with guns in their hands, but this kind
of army alone is not enough. We still need a cultural army, since
this kind of army is indispensable in achieving unity among ourselves
and winning victory over the enemy. Since May Fourth, when this
cultural army took shape in China, it has aided the Chinese revolu-
tion by gradually limiting the sphere of China's feudal culture and
the slavish culture[3] that serves imperialist aggression, and weaken-
ing their strength, so that now reactionaries are reduced to resisting

* Numbers in the text refer to the changes from the 1943/1944 text
to the 1953/1966 text, as listed in Appendix 1. All changes (ex-
cept punctuation) that survive translation are listed there.

new culture by "meeting quality with quantity": reactionaries aren't short of money, and with some effort they can turn out a lot even if they can't come up with anything worthwhile. Literature and art have formed an important and successful part of the cultural front since May Fourth. The revolutionary movement in literature and art, which developed considerably during the Civil War period, had the same general direction as the Red Army struggles[4] of that time, but there was no coordination between them in their actual work and each fought as an independent army.[5] The reason was that the reactionaries at that time kept the two fraternal armies apart. After the War of Resistance against Japan broke out, the number of workers in the field of revolutionary literature and art who came to Yan'an and other anti-Japanese bases increased, which was very good. However, coming to a base area is by no means the same thing as integrating with the people's movement[6] there, and if we want to push ahead with our revolutionary work, we must integrate these two forces completely. Our meeting today is to ensure that literature and art become a component part of the whole revolutionary machinery, so they can act as a powerful weapon in uniting and educating the people while attacking and annihilating the enemy, and help the people achieve solidarity in their struggle against the enemy. What are the problems which must be solved in order to achieve this purpose? They are[7] questions relating to our position, attitude, audience, work, and study.

The question of our position. We identify ourselves with the proletariat and the broad popular masses. Communist Party members must also identify themselves with the Party and with its basic character and policy. Is it true that some of our workers in literature and art still lack a clear and correct understanding of this question? I think so: many comrades have frequently strayed from their correct position.

The question of attitude. The question of the concrete attitude we are to take in regard to various concrete matters arises out of the question of our position. For example, whether to praise or expose something is a question of attitude. Which, ultimately, is the attitude we need to take? I would say that we need both kinds of attitudes; it all depends on whom we are dealing with. There are three kinds of people: our enemies, our friends,[8] and ourselves; that is, the proletariat[9] and its vanguard. A different attitude is required for each of these three kinds of people. Should we "praise" the enemy, Japanese fascists and all other enemies of the people?

Certainly not, because they are the very worst kind of reactionaries.
They may have some superiority on a technical level, so that we can
say, for example, that their guns and artillery are quite good, but
good weapons in their hands are reactionary. The task of our armed
forces is to capture their weapons and turn them against the enemy
to seize victory.[10] The task of our cultural army[11] is to expose the
enemy's atrocities, treachery, and inevitable defeat, and to encour-
age anti-Japanese forces to unite in complete solidarity to win a
decisive victory.[12] To our friends,[13] our allies of various kinds,[14]
our attitude should include unity and criticism according to the cir-
cumstances. We support their resistance to Japan, and we praise
any achievements they may make. But we should criticize and op-
pose[15] anyone who is anti-Communist and anti-people, who goes on
taking the road of reaction day after day. As for the popular
masses, we should obviously praise their toil and struggle, their
army and their party. Shortcomings exist even among the people:
many members of the proletariat still retain petty bourgeois ways of
thinking, and both peasants and petty bourgeoisie have backward
ways of thinking which hamper them in their struggle. We must
educate them patiently over a long period of time, helping them to
cast off this burden from their backs[16] so that they can advance
with rapid strides. They have either reformed themselves or are
in the process of reforming themselves in the struggle, and[17] our
literature and art should describe this process of their reform, in-
stead of ridiculing them in a very narrow-minded and mistaken way,
or even regarding them as some kind of enemy. What we write
should help them to unite, to make progress and to struggle forward
in complete solidarity, discarding their backward qualities and de-
veloping their revolutionary qualities. It certainly should not have
the opposite effect.

The question of audience is the question of for whom we are
writing. This problem is not the same in the anti-Japanese bases
in the Border Area,[18] northern China, and central China as in the
general rear[19] or[20] in pre-war Shanghai. In the Shanghai period,
the audience for revolutionary works of literature and art consisted
primarily of students, office workers, and shop assistants. In the
general rear[19] after the war broke out, this circle expanded a little,
but it still consisted primarily of the same people because the govern-
ment there has kept workers, peasants, and soldiers away from re-
volutionary literature and art. It is a completely different matter in
our base areas. The audience for works of literature and art here
consists of workers, peasants, and soldiers, together with their

cadres in the Party, the government, and the army.[21] There are
students in the base areas too, but they are either cadres already
or cadres of the future. Once they are literate, cadres of various
kinds, soldiers in the army, workers in factories, and peasants in
the countryside want books and newspapers, while people who aren't
literate want to see plays, look at pictures, sing songs, and listen
to music; they are the audience for our works of literature and art.
Just to take cadres alone, you shouldn't underestimate their num-
bers. They outnumber by far the readership for any book pub-
lished in the general rear, where one edition usually consists of
only two thousand copies, and even three editions only amount to
six thousand; while cadres in the base areas in Yan'an alone include
more than ten thousand who can read. What is more, many of these
cadres are mature revolutionaries who have endured many trials;
they come from all over China and they will go and work all over
China, so that educational work among these people is of immense
significance. Our workers in literature and art should work for them
very conscientiously.

Since the audience for literature and art consists of workers,
peasants, soldiers, and their cadres, the question then arises of
how to get to understand and know these people properly. To do
this, we must carry out a great deal of work in Party and govern-
ment organs, in villages and factories, in the Eighth Route Army
and the New Fourth Army, getting to understand all sorts of situa-
tions and all sorts of people and making ourselves thoroughly famil-
iar with them. Our workers in literature and art must carry out
their own work in literature and art, but the task of understanding
people and getting to know them properly has the highest priority.
How have our workers in literature and art performed in this respect
until now? I would say that until now they have been heroes without
a battlefield, remote and uncomprehending. What do I mean by re-
mote? Remote from people. Workers in literature and art are unfa-
miliar with the people they write about and with the people who read
their work, or else have actually become estranged from them. Our
workers in literature and art are not familiar with workers, peasants,
soldiers, or even their cadres. What do I mean by uncomprehending?
Not comprehending their language. Yours is the language of intel-
lectuals, theirs is the language of the popular masses.[22] I have
mentioned before that[23] many comrades like to talk about "populari-
zation," but what does popularization mean? It means that the
thoughts and emotions of our workers in literature and art should
become one with the thoughts and emotions of the great masses of

workers, peasants, and soldiers. And to get this unity, we should start by studying[24] the language of the masses. If we don't even understand the masses' language,[25] how can we talk about creating literature and art? "Heroes without a battlefield" refers to the fact that all your fine principles are not appreciated by the masses. The more you parade your qualifications before the masses, the more you act like "heroes," and the harder you try to sell your principles to them, the more the masses will resist buying. If you want the masses to understand you, if you want to become one with the masses, you must make a firm decision to undergo a long and possibly painful process of trial and hardship. At this point let me relate my own experience in how feelings are transformed. I started off as a student at school, and at school I acquired student habits, so that I felt ashamed to do any manual labor such as carry my own bags in front of all those students who were incapable of carrying anything for themselves. I felt that intellectuals were the only clean people in the world, and that workers, peasants, and soldiers[26] were in general rather dirty. I could wear clothes borrowed from an intellectual, because I considered them clean, but I would not wear workers', peasants', or soldiers' clothes, because I thought they were dirty. When I joined the revolution and lived among workers, peasants, and soldiers,[27] I gradually became familiar with them and they got to know me in return. Then and only then the bourgeois and petty bourgeois feelings taught to me in bourgeois schools began to undergo a fundamental change. Comparing intellectuals who have not yet reformed with workers, peasants, and soldiers,[26] I came to feel that intellectuals are not only spiritually unclean in many respects but even physically unclean,[28] while the cleanest people are workers and peasants; their hands may be dirty and their feet soiled with cow dung, but they are still cleaner than the big and petty bourgeoisie.[29] This is what I call a transformation in feelings, changing over from one class to another. If our workers in literature and art who come from the intelligentsia want their work to be welcomed by the masses, they must see to it that their thoughts and feelings undergo transformation and reform. Otherwise, nothing they do will turn out well or be effective.

The final question is study, by which I mean the study of Marxism-Leninism and the study of society. Anyone who calls himself a Marxist-Leninist[30] revolutionary writer, particularly a Party writer, must have a general knowledge[31] of Marxism-Leninism, but at the present time, some comrades still lack fundamental Marxist-

Leninist[30] ideas. For example, one fundamental idea in Marxism-Leninism[30] is that the objective determines the subjective;[32] that is, the objective reality of class struggle and national struggle determines our thoughts and feelings. However, some of our comrades turn this problem upside down: they say that everything should proceed from "love." Now love, in a class society, only exists as class love, but these comrades want to seek after some kind of love which goes beyond class, or love in the abstract; also abstract freedom, abstract truth, abstract human nature, and so on. This shows how deeply these comrades have been influenced by the bourgeoisie. They must eliminate this influence thoroughly and study Marxism-Leninism with an open mind free from prejudice. It is right that workers in literature and art should study literary and artistic creation, but Marxism-Leninism is a science that all revolutionaries must study, and workers in literature and art are no exception. In addition, you must study society, that is, you must undertake research on the various social classes, their mutual relations and individual circumstances, their outward features and their psychology. Only when these things have been clearly perceived can our literature and art become rich in content and take a correct direction.

Today I have only mentioned these things by way of an introduction; I hope that you will offer your opinions on these and other relevant questions.

CONCLUSION

(23 May 1942)

Comrades! Our conference has met three times this month, and in our search for truth several dozen party and non-party comrades have spoken, producing heated debates, bringing problems into the open and making them concrete; I believe that this will prove beneficial to the whole movement in literature and art.

When we discuss any problem we should start with facts rather than definitions. Looking up definitions of what constitutes literature or art in textbooks to use for setting goals for today's movement in literature and art, or for judging various opinions and controversies arising today, is the wrong approach. We are Marxists, and Marxism tells us that in dealing with problems we

should not start from abstract definitions but from objective facts, and that we should derive our goals, policy, and methods from an analysis of these facts. The same applies to our present discussion of the movement[33] in literature and art.

What are the facts at the present time? The facts are: the War of Resistance which China has been waging for five years; the world war against fascism; the indecisiveness[34] of the Chinese big landlord class and big bourgeoisie in the War of Resistance and their oppressive policies internally;[35] the revolutionary movement in literature and art since May Fourth—its great contribution to the revolution over the last twenty-three years and its many shortcomings; the anti-Japanese democratic base areas of the Eighth Route and New Fourth Armies and the integration of large numbers of workers in literature and art[36] with these armies;[37] the difference in circumstances and responsibilities between workers in literature and art in the base areas and those in the general rear;[38] the controversies and problems that have already arisen concerning work in literature and art in Yan'an and other anti-Japanese bases at the present time—these are actual and undeniable facts, and we must consider our problems on the basis of these facts.

Well, then, what is the central issue facing us? In my opinion, our problem is[39] fundamentally one of serving the masses and how to do this. If we do not solve this problem,[40] or if we do not solve it properly, then our workers in literature and art will not be attuned to their circumstances and responsibilities and will come up against a string of problems both internal and external. My conclusion will consist of some further explanation with[41] this problem[40] as the central issue and will also touch on a few other problems related to it.

1.

The first question is: who are the people our literature and art are for?[42] It may seem to comrades engaged in work in literature and art in our various anti-Japanese base areas that this problem has already been solved and does not require further mention. This is in fact not the case, since many comrades have certainly not found a clear and definite answer to this question. Therefore, in their emotions, works, actions, and views on the question of the goal of literature and art, to some extent a situation inevitably arises that is neither appropriate to the needs of the masses or the actual

struggle. Of course, although among the large number of cultural people, writers, artists, and workers in the field of literature and art in general who are now engaged in the great struggle for liberation along with the Communist Party, the Eighth Route Army and the New Fourth Army, there may be opportunists who will remain only temporarily, or even spies sent by the enemy or the Special Branch of the Nationalist Party masquerading as writers and artists,[43] nevertheless, apart from such people, the rest[44] work energetically for the common cause, and thanks to these comrades, great achievements have been made in all of our work in literature, drama, music, and art. Many of these workers in literature and art began to be involved in[45] this work after the War of Resistance broke out, but many others were engaged in revolutionary work for a long time even[46] before the war; they have undergone many hardships and have also influenced the broad masses both in their ordinary work and in their creative work. But why do we still say that even among these comrades there are some who have not clearly and definitely solved the question of who are the people our literature and art are for? Is it possible that they still maintain that literature and art are not for the popular masses but for exploiters and oppressors?

There is indeed such a thing as literature and art that serves exploiters and oppressors. The literature and art that serve the landlord class are feudal literature and art, that is, the literature and art of the ruling class in China during the feudal era. This kind of literature and art still has considerable influence to this day. The literature and art that serve the bourgeoisie are bourgeois literature and art; although people like Liang Shiqiu, who was criticized by Lu Xun, talk about some kind of literature and art that transcends class, in practice they uphold bourgeois literature and art and oppose proletarian literature and art. The literature and art that serve imperialism, represented by people like Zhou Zuoren and Zhang Ziping, is called slave culture or slave literature and art.[47] There is also another kind of literature and art, which serves the Special Branch and may be called "Special" literature and art: it may be "revolutionary" on the surface, but in reality it belongs with the three categories above.[48] For us, literature and art are not for those groups mentioned above but for the people. As we have said before, the new culture of China at its present stage is an antiimperialist, antifeudal culture of the popular masses under the leadership of the proletariat. Whatever genuinely belongs to the masses must be under the leadership of the popular masses. New literature and art, which are part of new culture, are

naturally in the same category.[49] We do not by any means refuse to use the old forms of the feudal class and the bourgeoisie,[50] but in our hands these old forms are reconstructed and filled with new content, so that they also become revolutionary and serve the people.

Well, then, who are the popular masses? The broadest section of the people, who constitute more than ninety percent of the total population, are workers, peasants, soldiers, and the petty bourgeoisie.[51] Therefore, our literature and art are in the first place for the workers, the class that leads the revolution. Secondly, they are for the peasants, the broadest and firmest allies in the revolution. Thirdly, they are for workers and peasants who have taken up arms, namely the Eighth Route Army, the New Fourth Army, and other popular armed forces; these are the chief strength in war.[52] Fourthly, they are for the petty bourgeoisie,[53] who are also allies in the revolution and can cooperate with us on a long-term basis. These four kinds of people constitute the largest sector of the Chinese nation and the broadest popular masses. We should also make alliances with anti-Japanese elements in the landlord class and bourgeoisie, but they do not support democracy among the broad popular masses. They have a literature and art of their own, while our literature and art are not for them and are in any case rejected by them.[54]

Our literature and art should be for the four kinds of people mentioned above. Workers, peasants, and soldiers are again the most important element in these four groups; the petty bourgeoisie are fewer in number, their revolutionary determination is weaker, and they have a higher cultural level than workers, peasants, and soldiers. Our literature and art are therefore primarily for workers, peasants, and soldiers, and only secondarily for the petty bourgeoisie. Here, we must not raise the petty bourgeoisie to a primary position and relegate workers, peasants, and soldiers to a secondary position.[55] The problem we now have with one group of comrades, or the key to their inability[56] to solve correctly the problem of who are the people our literature and art are for, is just this. I am not now talking about theory. On a theoretical level, that is,[57] in what they say, not a single person in our ranks would regard workers, peasants, and soldiers[58] as less important than the petty bourgeoisie.[59] I am talking about practice, or what they do: do they still regard members of the petty bourgeoisie[60] as more important than workers, peasants, and soldiers? I think they do. Many comrades place more emphasis on studying the intelligentsia[61] and analyzing their psychology; their main concern is to show their side of things, excusing and even defending their shortcomings, instead of guiding the intelligentsia from petty bourgeois backgrounds[62] and themselves as well towards closer contact with workers, peasants, and soldiers,[58]

to take part in their actual struggles, to show how things are with them
and educate them. Coming from a petty bourgeois background and be-
ing themselves intellectuals, many comrades only look for friends among
the ranks of the intelligentsia and focus their attention on studying and
describing them. This would be quite proper if they did so from a pro-
letarian position. But that is not the case at all, or only partly so. They
identify themselves with the petty bourgeoisie and their creative work
is designed to act as a means of self-expression for the petty bourgeoi-
sie; we have seen this sort of thing in a fairly large number of works of
literature and art. Many times they express heartfelt sympathy for the
intelligentsia from petty bourgeois backgrounds, and even the short-
comings of the petty bourgeoisie[63] win their sympathy or actual encour-
agement. But when it comes to workers, peasants, and soldiers,[64]
these people don't have any contact with them, don't understand them,
don't study them, don't have close friends among them, and are no good
at describing them. They can dress their characters up as workers,
peasants, and soldiers,[65] but these characters still have petty bour-
geois[66] faces. They do like some things about workers, peasants, sol-
diers, and cadres from worker-peasant-soldier backgrounds, but they
don't like them all the time or everything about them: they don't like
their emotions, their manner, or their budding literature and art (wall
newspapers, murals, folk songs, folk tales, popular speech,[67] and so
on). Sometimes they even like these things, too, either out of curiosity
or because they want to decorate their own work with them, or even to
look for backward things about them. At other times they openly de-
spise these things in their infatuation with the works of the intelligen-
tsia, the petty bourgeoisie,[68] or even the bourgeoisie itself. These
comrades still have their arses[69] on the side of the petty bourgeoisie,[59]
or to put it more elegantly, their innermost souls are still in the kingdom
of the petty bourgeoisie.[59] This is why they haven't yet solved the pro-
blem of what sort of people to serve, or haven't solved it clearly and de-
finitely. I'm not simply talking about people who haven't been in Yan'an
for long; even people[70] who have been to the front and who have car-
ried out work in the base areas, the Eighth Route Army, or the New
Fourth Army for several years, still haven't arrived at a thorough-
going solution. It may take as long as eight to ten years before this
problem can be settled once and for all. But no matter how long it
takes, it must be settled, and settled clearly, definitely, and thor-
oughly. Our workers in literature and art must fulfill this responsi-
bility and shift their arses;[71] they must gradually move over to the
side of the workers, peasants, and soldiers[72] by entering deeply into
their ranks and the actual struggle, and studying Marxism-Leninism[73]
and society; this is the only way we can have literature and art
that genuinely serve workers, peasants, and soldiers[74].

The question of what sort of people we serve is a fundamental question, a question of principle. The controversies, disagreements, opposition, and disunity that have existed among comrades in the past have not been concerned with this fundamental question of principle, but with rather secondary questions that may not involve principles at all. But when it came to this question of principle, however, there was no real disagreement but almost unanimity on both sides, since both to some extent had a tendency to despise workers, peasants, and soldiers and to isolate themselves from the masses; I say to some extent, because generally speaking, the way in which these comrades despised workers, peasants, and soldiers and isolated themselves from the masses differs in some respects[75] from the behavior of the Nationalist Party; but nevertheless, this tendency does exist, and unless the fundamental question is settled, it won't be easy to settle many other questions either. Take sectarianism in the literary and art world, for instance, which is also a question of principle; the only way to get rid of sectarianism is by raising the slogan, "Serve the workers and peasants, serve the Eighth Route and New Fourth Armies, and go among the masses," and actually carrying it out in practice; otherwise, the problem of sectarianism will never be solved. Lu Xun has said that disunity on the front of revolutionary literature and art is caused by lack of a common purpose, and that this common purpose is to serve the workers and peasants.[76] The same problem existed then in Shanghai, and now it also exists in Chongqing; it is very difficult to solve it thoroughly in such places because people[77] there oppress revolutionary writers and artists and do not allow them freedom to go among the masses of workers, peasants, and soldiers. Conditions here with us are completely different: we encourage revolutionary writers and artists to develop positive contacts with workers, peasants, and soldiers, we give them complete freedom to go among the meases, and we give them complete freedom to create genuinely revolutionary literature and art; we have therefore come close to solving the problem here. But coming close to solving a problem isn't the same as solving it completely and thoroughly; our insistence on studying Marxism-Leninism[78] and society is just for this purpose, a complete and thorough-going solution. What we mean by Marxism-Leninism[78] is a living Marxism-Leninism,[78] which is fully applicable[79] in the life and struggles of the masses, and not a Marxism-Leninism[78] which only comes from books.[80] If we move this Marxism-Leninism out of books and into the masses so that it becomes a living

Marxism-Leninism,[81] sectarianism will be impossible, and many other problems apart from sectarianism can be solved.

2.

Once the question of what kind of people we serve has been solved, the next problem is how to go about it. In your own words, should we put our efforts into raising standards or into reaching a wider audience?

A few comrades, some more seriously than others, have in the past despised or ignored the work of reaching a wider audience and have exaggerated out of all proportion the work of raising standards. Raising standards should be stressed, but it is wrong to exaggerate it out of all proportion.[82] The[83] lack of a clear and definite solution to the question of what sort of people we serve, which I spoke of above, is also evident in this question. Since[84] there is no clear understanding of what people to serve, there aren't any correct criteria for their discussions on reaching wider audiences or raising standards, while the correct relationship between the two is of course even more difficult to find. Since our literature and art are fundamentally for workers, peasants, and soldiers, reaching a wider audience means reaching a wider audience among them, and raising standards means raising standards among them. What are we trying to reach them with? Feudal things?[85] Bourgeois things?[86] Petty bourgeois things?[87] None of these will do: we must use what belongs to[88] workers, peasants, and soldiers themselves, and therefore, the task of learning from workers, peasants, and soldiers comes before the task of educating them. This is even more true of raising standards. There must be a basis from which standards are raised; for example, a bucket of water is raised from the ground, it can hardly be raised from midair. Well, then, where do we start off from? From a feudal basis? From a bourgeois basis? From a petty bourgeois[89] basis? None of these will do: we must raise standards on the basis of workers, peasants, and soldiers,[90] on the basis of their present cultural level and their budding literature and art.[91] Instead of raising workers, peasants, and soldiers to feudal, bourgeois, or petty bourgeois[89] heights[92], we raise their standards in the direction of their own development[93]. Here, too, the task of learning from workers, peasants, and soldiers arises. Only by starting from workers, peasants, and soldiers can

we gain a correct understanding of what it means to reach a wider audience and to raise standards, and find the correct relationship between them.

Reaching a wider audience and raising standards are both worthy activities, but from what source do they arise?[94] Works of literature and art, as conceptualized forms on whatever level of operation,[95] are the result[96] of the human mind reflecting and processing[97] popular life[98]; revolutionary literature and art are thus the result[96] of the revolutionary's mind reflecting and processing[97] popular life. Rich deposits of literature and art[99] actually exist in popular life itself: they are things in their natural forms, crude but also extremely lively, rich, and fundamental;[100] they make all processed forms of[101] literature pale in comparison, they are the sole and inexhaustible source of processed forms of literature and art. They are the sole source, because only this kind of source can exist; no other exists[102] apart from it. Someone may ask whether works of literature and art in book form, classical or foreign works, aren't also a source. Well, you can say they are a source, but a secondary and not a primary one[103]; it would be a distorted way of looking at things to regard them as primary. In fact, books and other works already in existence[104] are not the source but the flow, they are things that the ancients and foreigners processed and fabricated from the literature and art[105] they perceived[106] in popular life in their own time and place. We must absorb these things[107] in a discriminating way, using them as models from which we may learn what to accept or what to reject[108] when we process works of literature and art as conceptualized forms[109] from the literature and art[110] in popular life in our own time and place. It makes a difference to have this model, the difference between being civilized or vulgar, crude or refined, advanced or elementary, fast or slow; therefore, we certainly may not reject the ancients and foreigners as models,[111] which means, I'm afraid, that we must even use feudal and bourgeois things. But they are only models and not substitutes;[112] they can't be substitutes. Indiscriminate plagiarization, imitation, or substitution[113] in literature and art of dead people[114] or foreigners is an extremely sterile and harmful literary and artistic dogmatism, of the same basic nature as dogmatism in military, political, philosophical, or economic matters.[115] Revolutionary Chinese writers and artists, the kind from whom we expect great things, must go among the masses; they must go among the masses of workers, peasants, and soldiers and into the heat of battle for a long time to come, without reservation, devoting body and soul[116]

to the task ahead; they must go to the sole, the broadest, and the richest source, to observe, experience, study, and analyze all the different kinds of people, all the classes and all the masses, all the vivid patterns of life and struggle, and all literature and art in their natural form,[117] before they are ready for the stage of processing or creating,[118] where you integrate raw materials with production, the stage of study with the stage of creation.[119] Otherwise, there won't be anything for you to work on, since without raw materials or semiprocessed goods you have nothing to process[120] and will[121] inevitably end up as the kind of useless writer or artist that Lu Xun in his will earnestly instructed his son never to become.

Although literature and art in their natural form are the sole source of literature and art in conceptualized form,[122] and although the former is incomparably more vivid and interesting, nevertheless, people are still not satisfied with the former and demand the latter; why is this? It is because while both are beautiful, literature and art that have been processed are more organized and concentrated than literature and art in their natural form;[123] they are more typical and more idealized, and therefore have greater universality. The living Lenin was infinitely more vigorous and interesting than the Lenin of fiction, drama, and film, but the living Lenin did so many things in the course of a single day, and so much of what he did was identical with other people's work; besides, very few people ever saw Lenin, and after his death no one could ever see him again. In these respects the Lenin of fiction, drama, and film is superior to the living Lenin.[124] Revolutionary fiction, drama, film, and so on[125] can[126] create all sorts of characters on the basis of real life and help the masses push history forward. For example, some people suffer from hunger[127] and oppression while others exploit and oppress them: this state of affairs exists everywhere and no one gets upset about it; but literature and art organize and[128] concentrate this kind of everyday occurence, making it typical[129] and creating a work of literature and art which can awaken and arouse the popular masses, urging them on to unity and struggle and to take part in transforming their own environment. If there were no processed literature and art,[130] but only literature and art in their natural form,[131] it would be impossible to accomplish this task or at least to do it as powerfully and speedily.

Literature and art for a wider audience and literature and art to raise standards are both processed forms, so what is the difference between them? There is a difference of degree.[132]

Literature and art for a wide audience indicates that the processing
has been relatively limited and crude,[133] and therefore relatively
easy for the broad popular masses at the present time to accept
readily, while literature and art to raise standards indicates that
the processing has been relatively extensive and skillful, and hence,
relatively difficult for them.[134] The problem which now faces
workers, peasants, and soldiers is that they are engaged in a bitter
struggle[135] with the enemy and yet they are illiterate, ignorant, and
uncultured[136] as a result of prolonged feudal and bourgeois rule;
their most urgent demand, therefore, is for a wide-reaching educa-
tional movement in the form of cultural knowledge and works of lit-
erature and art that they urgently need and can readily accept,[137]
which will heighten their ardor in the struggle and faith in victory,
strengthen their unity, and make them struggle against the enemy
in full solidarity. The first step for them is not a question of[138]
"pinning flowers on brocade" but "sending charcoal in the snow."
The most serious and central task in regard to the people, there-
fore, is initially the work of reaching a wider audience rather than
raising standards.[139] The attitude of despising or ignoring the
work of reaching a wider audience is a mistaken one.

There is, however, no hard and fast line between the work
of reaching a wide audience and raising standards. If the people
providing the material for wider audiences aren't on a higher level
than their audience, then what is the point of trying to reach them
at all?[140] If their material stays constantly on the same level month
after month and year after year, invariably[141] consisting of the
same old stock-in-trade like "The Little Cowherd" or "man, hand,
mouth, knife, cow, sheep," then what is there to choose between
the people who prepare the material and the audience they are
reaching?[142] Wouldn't it be pointless[143] to reach a wider audience
in this way? The people demand material that can reach a wide
audience, but they also demand higher standards, standards that
continue to rise month by month and year by year. Here, raising
standards, like reaching a wider audience, is a popular concern;
it does not take place in thin air or behind closed doors, but on the
basis of reaching to a wider audience; it is determined by the needs
of a wider audience and at the same time it acts as a guide to reach-
ing a wider audience. In the case of China, the development of
revolution and revolutionary culture has been uneven and their ex-
pansion gradual, so that in some places wider audiences have been
reached and standards have been raised on that basis, while else-
where we have not even begun to reach a wider audience; the

experience[144] gained in one area from reaching a wider audience and
raising standards can therefore be applied in other areas, giving
guidance to this kind of work to keep it on the right track there.
In the international sphere, the experience of foreign countries, es-
pecially of the Soviet Union, can be used to guide our work of reach-
ing a wider audience and raising standards,[145] provided that their
experience is good.[146] In raising standards, therefore, we proceed
on the basis of reaching a wider audience; in reaching a wider audi-
ence we proceed under the guidance of raising standards. But the
material used in raising standards for guidance never involves crude
imitation, since this would only destroy its usefulness.[147]

In addition to the direct need on the part of the masses for
higher standards, they have also an indirect need, that is, the
cadres' need for higher standards. Cadres are the advanced element
among the masses, who have generally already completed the kind of
education currently offered to the masses;[148] their ability to absorb
things is higher than the masses, so that material intended for wider
audiences among the masses at their present level, such as "The
Little Cowherd," cannot satisfy them.[149] Literature and art on a
higher level are absolutely essential for them. But for the time
being this kind of need is confined to cadres and not generally felt
among the masses; it should be our goal to meet this need, but it
should not become the total or the central goal today.[150] At the
same time we should understand that in serving cadres[151] we are
still wholly concerned with serving the masses, since we rely on
cadres to educate and guide the masses. If we violate this aim, and
give cadres material that can't help them educate and guide the
masses, there would be no point in our trying to raise standards,
and we would be departing from our fundamental principle of serving
the popular masses.

To sum up, the raw material of literature and art in popular
life undergoes processing[152] by revolutionary writers to become
literature and art in conceptual form, which serve the popular mas-
ses; they include both an advanced mass literature and art,[153] de-
veloped on the basis of lower-grade mass literature and art[154] and
serving the needs of the masses whose standards have been raised,
primarily mass cadres, as well as a lower-grade mass literature and
art,[154] which in their turn come under the guidance of advanced
mass literature and art[153] and serve[155] the primary needs of the
broad masses today (which isn't to say literature and art with low
standards of taste).[156] Whether at a high level or a low one, our

literature and art serve the popular masses, primarily workers, peasants, and soldiers; they are created for workers, peasants, and soldiers and are used by them.

Now we have settled the question of the relationship between raising standards and reaching a wider audience, the question of the relationship between professional experts and comrades[157] who carry out the work of reaching wide audiences can also be settled. Our professionals should serve not only cadres but more importantly the masses as well. Gorky was active in editing factory histories, guiding village correspondents, and guiding young people in their teens, while Lu Xun also spent a great deal of time on general correspondence with students.[158] Our professional writers should give their attention to the masses' wall newspapers and to reportage literature in the army and the villages. Our professional playwrights should give their attention to little theater groups in the army and villages. Our professional musicians should give their attention to songs sung by the masses. Our professional artists should give their attention to mass art. All of these comrades should develop close relationships with comrades who are doing the work of reaching wider audiences on the lowest level[159] among the masses, helping and guiding them at the same time as learning from them and drawing sustenance from them, replenishing, enriching, and nourishing themselves[160] so that their profession does not become an ivory tower isolated from the masses and from reality, devoid of meaning and vitality. We should respect professionals, who are very valuable to us in our cause. But we should tell them that their work as revolutionary writers and artists can only have significance if they ally themselves with the masses, express their point of view, and become their loyal spokesmen. The only way to educate the masses is by being their student. If professional writers and artists regard themselves as masters of the masses, as aristocrats on a superior level to "the lower classes," then no matter how talented they might be, they are completely useless as far as the masses are concerned and there is no future for their work.

Is this attitude of ours utilitarian? Materialists do not oppose utilitarianism in general, but they do oppose feudal, bourgeois, or petty bourgeois utilitarianism, not to mention the kind of hypocrite who opposes utilitarianism in words but practices the most selfish and short-sighted kind of utilitarianism. There is no such thing as super-utilitarianism in this world; in a class society, utilitarianism is a property of class. We are proletarian, revolutionary utilitarians, who take as our starting point a combination of the present and

future interests of the broad masses who constitute over ninety per-
cent of the total population; we are therefore revolutionary utilitari-
ans who adopt an extremely broad and long-range target, rather
than guild utilitarians[161] who are only concerned with the partial
and the immediate. For instance, if someone tries to foist on the
market and propagate among the masses a work that appeals only
to himself and his friends or a small group of people,[162] but which
the majority does not need and which may even be harmful to it, all
for the sake of promoting his own interests or those of a narrow
group, and yet still finds fault with utilitarianism among the masses,
then not only is he insulting the masses but also showing a total
lack of self-knowledge. Nothing can be considered good unless a
large number of people benefit greatly from it.[163] Suppose you have
something like "Snow in Spring" which aristocrats enjoy[164] while the
masses are still singing "The Sichuanese in the Countryside"; if
all you can be bothered to do is curse the masses without trying
to raise their standards, then all your curses are useless. The pro-
blem at the present time is to combine "Snow in Spring" with "The
Sichuanese in the Countryside," which is a problem of combining
higher standards with wider audiences. If we don't combine them,
professional literature and art of even the highest quality will inevi-
tably turn into the narrowest utilitarianism; you may say it is pure
and lofty, but that's only your judgment, the masses won't accept
it. Once we have settled the problem of serving the masses and how
to go about it as our fundamental goal, we have in so doing settled
all the other questions[165] such as position, attitude, audience,
material,[166] the description of dark and bright sides, alliance ver-
sus opposition,[167] utilitarianism versus super-utilitarianism and
narrow utilitarianism versus long-range utilitarianism.[168] If we[169]
agree on the fundamental goal, then our workers in literature and
art, our schools for literature and art, our publications, organiza-
tions, and activities of every kind in literature and art should serve
this goal.[170] It would be a mistake to depart from this goal, and
anything at variance with it must be revised accordingly.

3.

Since our literature and art are for the popular masses, we
can now discuss two further questions, the first concerning the
relationships within the party, i.e., the relation between party
work in literature and art and party work as a whole, the other con-
cerning relationships that go outside the party, i.e., the relation

between party and nonparty work in literature and art—the question of the united front in literature and art.

Let us start with the first question. In the world today, all culture or literature and art belongs to a definite class and party,[171] and has a definite political line. Art for art's sake, art that stands above class and party,[171] and fellow-travelling or politically independent art do not exist in reality. In a society composed of classes and parties, art obeys both class and party and it must naturally obey the political demands of its class and party, and the revolutionary task of a given revolutionary age; any deviation is a deviation from the masses' basic need.[172] Proletarian literature and art are a part of the whole proletarian revolutionary cause; as Lenin said, they are "a screw in the whole machine,"[173] and therefore, the party's work in literature and art occupies a definite, assigned position within the party's revolutionary work as a whole[174]. Opposition to this assignment must lead to dualism or pluralism, and in essence resembles Trotsky's "Politics—Marxist; art—bourgeois." We do not support excessive emphasis[175] on the importance of literature and art, nor do we support their underestimation. Literature and art are subordinate to politics, and yet in turn exert enormous influence on it. Revolutionary literature and art are a part of the whole work of revolution; they are a screw,[176] which of course doesn't compare with other parts[177] in importance, urgency, or priority, but which is nevertheless indispensible in the whole machinery, an indispensible part of revolutionary work as a whole. If literature and art did not exist in even the broadest and most general sense, the revolution[178] could not advance or win victory; it would be incorrect not to acknowledge this. Furthermore, when we speak of literature and art obeying politics, politics refers to class and mass politics and not to the small number of people known as politicians. Politics, both revolutionary and counterrevolutionary alike, concerns the struggle between classes and not the behavior of a small number of people. Ideological warfare and literary and artistic warfare, especially if these wars are revolutionary, are necessarily subservient to political warfare,[179] because class and mass needs can only be expressed in a concentrated form through politics. Revolutionary politicians, professional politicians who understand the science or art of revolutionary politics, are simply the leaders of millions of mass politicians; their task is to collect the opinions of mass politicians, distill them, and return them to the masses in an acceptable and practical form; they are not like the kind of aristocratic or armchair "politician" who

acts as if he had a monopoly on brilliance—this is the difference in principle between politicians of the proletariat and the propertied[180] classes, a difference that also exists between their respective politics.[181] It would be incorrect not to acknowledge this or to see proletarian politics and politicians in a narrow or conventional[182] way.

The second topic is the question of the united front in literature and art. Literature and art are subordinate to politics, and the first and fundamental problem in China today is resistance to Japan; therefore, party workers in literature and art should form an alliance on this issue with writers and artists outside the party (from party sympathizers and petty bourgeois writers and artists to bourgeois and landlord writers and artists[183]). Next, they should form an alliance around the issue of democracy; some writers and artists[184] do not support this issue, so the extent of the alliance here will inevitably be somewhat smaller. Thirdly, they should form an alliance around specific questions among writers and artists—issues of artistic style.[185] We advocate proletarian realism,[186] which again some people do not support, and the extent of the alliance here will probably[187] even be smaller. There may be unity on one question at the same time as there is struggle or criticism on another. Each question is both separate from and connected with the others, so that struggle and criticism continue to exist even on questions where an alliance has been formed, such as resistance to Japan. United front errors, such as alliance without struggle or struggle without alliance, or practicing as some comrades have done in the past either rightist capitulationism and tailism or "leftist" isolationism and sectarianism, all come under the heading of what Lenin called a hamstrung policy.[188] This is just as true in art as it is in politics.

Petty bourgeois writers and artists are an important force in China among the various forces constituting the united front in literature and art. There are many shortcomings in their thinking and their works, but they show some tendency towards revolution and are fairly close to workers, peasants, and soldiers.[189] It is therefore a particularly important task to help them overcome their shortcomings and win them over to the front that serves the masses of workers, peasants, and soldiers.[190]

4.

One of the chief methods of struggle among writers and artists is literary or art criticism. We should develop criticism in literature and art: our past work has been deficient[191] in this regard, as our comrades have correctly pointed out. Literary criticism is a complex problem that requires a great deal of specialized study. Here I shall only discuss[192] the fundamental question of the criteria to be used, along with a brief outline of my opinions on a number of miscellaneous[193] questions and incorrect views raised by some comrades.

There are two criteria in literary criticism, the political and the artistic. According to the political criterion, everything that is in the interests of unity in the War of Resistance, encourages solidarity among the masses, opposes retreat and promotes progress is good or better,[194] while everything that is not in the interests of unity in the War of Resistance, encourages a lack of solidarity among the masses, opposes progress or drags people backwards is bad or worse.[195] Do the words good and bad in this context refer to motive (subjective desires) or to effect (social practice)? Idealists stress motive and deny effect, while mechanical materialists stress effect and deny motive; as dialectical materialists who believe in the unity of motive and effect, we are opposed to both of these approaches. Motives to serve the masses, and effects that win the approval of the masses, cannot be taken separately; the two must be unified. Motives that serve the interests of narrow groups or individuals are no good, but neither are effects that don't win the approval of the masses or aren't in their interests despite a motive to serve them. In examining a writer's subjective desires, whether his motives are correct and upright, we don't go by his declarations but rather by the effect that his actions (his works)[196] produce among the masses in society. The criterion for examining subjective desires is social practice; the criterion for examining motives is their effect. We don't want sectarianism in our literary criticism or art criticism; according to the general principle of alliance in the War of Resistance, we should tolerate works[197] of literature and art that contain different kinds of political attitudes, but our criticism still takes a firm stand on principle, and we must pass strict judgment on[198] works of literature and art that contain antinational, antiscientific, antimass, and antiparty views, because these kinds of so-called literature and art, both in motive and effect, damage unity in the War of Resistance. According to the artistic criterion, all works of higher artistic standards are good or better, while those of lower artistic standards are bad or worse; but even in making

this distinction we must naturally consider social effect. There is hardly any writer or artist who doesn't think his own work is excellent, and our criticism should allow free competition between different kinds of work; but it is also absolutely necessary to subject them to correct criticism according to scientific artistic standards, gradually raising relatively low levels of art to higher levels and transforming art that doesn't meet the demands of the broad mass struggle (even if it is on a very high level of art)[199] into art that does. Given both political and artistic criteria, what is the relationship between them? Politics is certainly not equivalent to art, and a general world outlook is certainly not equivalent to a methodology of artistic creation.[200] In art, just as in politics, we do not acknowledge abstract and absolutely unchanging criteria, since in every class society and in every class in that society[201] there are different political and artistic criteria. But in every class society and in every class within that society,[201] without exception, political criteria are always placed ahead of artistic criteria. The bourgeoisie always rejects a proletarian work of literature or art however high its artistic quality.[202] The proletariat must also reject the reactionary political qualities of bourgeois works of literature and art and accept their artistic qualities only with discrimination.[203] There are some things which are fundamentally reactionary in political terms, and yet can have a certain artistry, for example, fascist literature and art.[204] Insofar as a work is reactionary, the more artistic it is the more harm it can do to the people and the more it should be rejected. The common characteristic of all literature and art of exploiting classes in their period of decline is the contradiction between their reactionary political content and their artistic form. What we demand, therefore, is a unity of politics and art, a unity of content and form, a unity of revolutionary political content and the highest[205] artistic form possible. Works of art that lack artistry, however progressive politically, are nevertheless ineffectual. We are therefore equally opposed to works of art with a harmful content[206] and to the tendency toward the so-called "slogan style," which is only concerned with content and not with form;[207] we should carry out a struggle on both fronts in questions of literature and art.

Both of these tendencies exist among many of our comrades.[208] Many comrades have a tendency to ignore art and should pay attention to raising their artistic standards. But what I believe is more of a problem at present is still the political aspect. Some comrades, lacking a fundamental knowledge of politics, have come

up with all sorts of foolish ideas. Let me give you a few examples from Yan'an.

"Humanism." Is there such a thing as human nature? Of course there is. But human nature only exists in the concrete[209]; in a class society human nature has[210] a class character, and human nature in the abstract,[211] going beyond class, doesn't exist. We uphold the human nature of the proletariat,[212] while the bourgeoisie and the petty bourgeoisie[213] uphold the human nature of their own class, although they don't talk about it as such but make it out to be the only kind there is[214]; in their eyes, therefore, proletarian human nature is incompatible with human nature. The so-called[215] "humanism" which some people in Yan'an at the present time uphold as a[216] theoretical basis for literature and art goes along these lines and is completely mistaken.

"The fundamental starting point of literature and art is love, the love of mankind." Love may be one starting point, but there is a more fundamental one. Love exists on a conceptual level, as a product of objective practice, and it is a fundamental principle that we do not start from concepts but from objective practice. The fact that our workers in literature and art who come from the intelligentsia love the proletariat stems from the fact that society has sentenced both to a common fate and integrated our two separate lives into one.[217] Our hatred of Japanese imperialism stems from the fact that Japanese imperialism oppresses us. Nowhere in the world does there exist love or hatred without cause or reason. As for so-called "love of mankind," there has never been this kind of unifying love since mankind split[218] into classes. The ruling classes, Confucius, and even Tolstoy all upheld it,[219] but no one has genuinely practiced it because it would be impossible in a class society. A genuine love for mankind will be possible when classes have been eliminated all over the world. Classes cause splits within society,[220] and only when classes have been eliminated and unity restored[221] in society will love for the whole of mankind exist; at the present time, however, it doesn't yet do so. We cannot love fascists,[222] the enemy or all the ugly and vicious things in society, since our aim is to eliminate them; this is just commonsense; it's hard to believe that some workers in literature and art still can't understand it!

"Works of literature and art have always given equal weight to descriptions of brightness and darkness, on a fifty-fifty basis." There are a lot of muddled ideas contained here. It's certainly not

the case that works of literature and art always used to be like this.
Many petty bourgeois writers have never found the brightness, and
their works only expose darkness, under the name of "exposure
literature"; some actually specialize in spreading pessimism and
cynicism. Soviet Russian literature, on the other hand, in a period
of socialist reconstruction, concentrates on descriptions of bright-
ness; it also describes shortcomings in work,[223] but these short-
comings[224] only form a contrast to the overall picture of brightness;
there is certainly no question of a "fifty-fifty basis." Bourgeois
writers and artists in their reactionary phase describe the revolu-
tionary masses as hooligans and themselves as saints, which can be
called reversing brightness and darkness. Only genuinely revolu-
tionary writers and artists can settle correctly the problem of praise
and exposure. They must expose every dark force that endangers
the popular masses, and praise every revolutionary struggle of the
popular masses: this is their fundamental task.

"The task of literature and art has always been exposure."
Explanations like this one and the one above show a lack of under-
standing of the science of history and historical materialism.[225] I
have already explained above that literature and art have by no
means always been confined to exposure. The only targets that
revolutionary writers and artists can take for exposure are aggres-
sors, exploiters, and oppressors,[226] not the popular masses. There
are shortcomings among the popular masses too, but these are chiefly
a result of the rule exercised over them by aggressors, exploiters,
and oppressors, so that our revolutionary writers and artists should
expose them as evils for which aggressors, exploiters, and oppres-
sors are responsible;[227] but there shouldn't be any kind of "expos-
ing the people" as such. Our attitude towards the people is only[228]
a question of educating them and raising standards among them. No
one but counterrevolutionary writers and artists describe the peo-
ple as "born stupid" and the revolutionary masses as "tyrannical
hooligans."

"It is still the age of essays, and we still need the Lu Xun
style." If we take the essay and the Lu Xun style just to mean
satire, then this view is only correct when it applies to enemies of
the people.[229] Lu Xun lived under the rule of the forces of dark-
ness, where there was no freedom of speech, and it was therefore
absolutely correct of Lu Xun to use the essay form, with its cold
ridicule and burning satire, to do battle. We also have a need for
sharp ridicule to direct at fascism and Chinese reactionaries,[230]

but in anti-Japanese bases in the Shaanxi-Gansu-Ningxia Border Areas and elsewhere behind the enemy lines, where revolutionary writers and artists are given complete democratic freedom and only counterrevolutionary and Special Branch[231] elements are denied it, the essay should not take[232] the same form as Lu Xun's; it can shout at the top of its voice, but it shouldn't be obscure or devious, something that the popular masses can't understand.[233] When it came to the people themselves and not their enemies, Lu Xun even in his "essay period" never ridiculed or attacked revolutionary people or parties, and his style in these essays was completely different from the style he employed against the enemy. I have already said above that the people's shortcomings must be criticized, but we must speak from genuine identification with the people and total devotion to their protection and education. If we treat comrades with the ruthless methods required against the enemy,[234] then we are identifying ourselves with the enemy. Should we get rid of satire?[235] There are[236] several kinds of satire, for use against the enemy, friends,[237] or our own ranks; each of these three attitudes [238] is different. We certainly won't get rid of[239] satire in general, but we must get rid of its indiscriminate use.

"I am not in the habit of celebrating success or praising virtue; works that praise brightness are not necessarily great, nor are works that portray darkness necessarily trivial." If you are bourgeois writers and artists, you praise the bourgeoisie and not the proletariat, and if you are proletarian writers and artists, then you praise the proletariat and the laboring people, but not the bourgeoisie: each takes its own side. Works that praise the bright side of the bourgeoisie are not necessarily great, and works that portray its dark side are not necessarily trivial; whereas works that praise the bright side of the proletariat are not necessarily less than great, but works that portray its "darkness" are definitely[240] trivial: isn't this a fact of literary and art history? What is wrong with praising the people, the creators of this world and of history?[241] What is wrong with praising the proletariat, the Communist Party, new democracy, and socialism? A type of person does actually exist who has no enthusiasm at all for the popular cause and maintains a cold, detached attitude toward the struggle and victory of the people[242] and their vanguard; the only thing he is interested in and never tires of praising is his own self and perhaps his sweetheart as well, plus[243] a few celebrities from his own clique. This kind of petty bourgeois individualist

naturally doesn't want to praise the achievements of revolutionary people or inspire them to courage in battle and faith in victory. A type like this is only a termite in the revolutionary ranks, and the revolutionary people don't need his "praise."

"It is not a question of position; my position is right, my intentions are good, and I understand the issues, but because my expression is bad my work ends up having the wrong effect." I have already explained above the dialectical materialist view of the relation between motive and effect; now I want to ask whether or not the question of effect is a question of position. For someone to perform a task solely on the basis of his motives and not bother about its effect is equivalent to a doctor only being concerned with making out prescriptions and not caring whether[244] his patients die as a result, or like a political party only being concerned with issuing manifestos and not bothering to see whether they are carried out or not; how is a position like this still correct? Are the intentions still good? Of course, even when we take into account the possible effect of something beforehand, mistakes can still occur, but are our intentions still good if we persist in doing something that has already been shown to have a bad effect in practice? We judge parties or doctors by looking at their practice or their results, and the same is true of writers. Genuinely good intentions necessarily involve considering the effects of what we do, summarizing our past experience, and studying various methods or what are known as[245] techniques of expression. They must involve totally sincere self-criticism of shortcomings and mistakes in our work and a firm resolution to correct them. This is how the method of self-criticism among communists was adopted. This is the only position that is correct. At the same time, the only way we can come to understand what the correct position is and maintain our grasp on it is through a process of serious and responsible practice along these lines. If we don't advance along these lines in our practice and just say complacently that "we understand," we haven't really understood at all.

"Studying[246] Marxism-Leninism[247] leads to repeating the mistakes of the dialectical materialist method of creative work, which hinders creativity." Studying Marxism-Leninism[247] only[248] requires us to observe the world, society, literature, and art from the point of view of dialectical materialism and historical materialism; it certainly doesn't require us to write lectures on philosophy in works of literature and art. Marxism-Leninism[247] can include

but not replace realism in literary and artistic creation, just as it can include but not replace theories of the atom or electron in physics. It's true that empty, dry, and dogmatic formulas will destroy creativity, but more than that, they will first destroy Marxism-Leninism.[247] Dogmatic Marxism-Leninism[249] is not Marxism-Leninism[247] at all but anti-Marxism-Leninism.[247] Then Marxism-Leninism[247] won't destroy creativity after all? Yes, it will, it will definitely destroy feudal, bourgeois, petty bourgeois, liberalist, individualist, nihilist, art-for-art's sake, aristocratic, decadent, pessimistic, and other kinds of creativity that are alien to the popular masses and the proletariat. Should mentalities like these be destroyed among proletarian writers and artists? Yes, I think so, they should be thoroughly destroyed, and while they are being destroyed, something new can be established.

<div align="center">5.</div>

What does the existence of these questions among our writers and artists in Yan'an tell us? It tells us that three[250] incorrect working styles still exist to a serious degree among our writers and artists, and that many shortcomings such as idealism, foreign dogmatism,[251] idle speculation, contempt for practice, and isolation from the masses still exist among our comrades, a situation that requires a realistic and serious movement to correct our work styles.

Many of our comrades are still not very clear about the difference between the proletariat and the petty bourgeoisie. Many party members have joined the party on an organizational level, but haven't made a full commitment on the ideological level, or even any commitment at all; these people still carry around a lot of exploiter's filth in their heads and are fundamentally ignorant of what proletarian ideology, communism, and the party are. They think that proletarian ideology is just the same old story. Little do they realize that it is by no means easy to acquire: some people spend a lifetime without ever getting close to being a true party member and invariably end up leaving the party. Of course, some people are even worse: on the organizational level, they join the Japanese party, Wang Jingwei's party, or the Special Branch of the big bourgeoisie and big landlords party, but afterwards they also bore their way into the Communist party or Communist-led organizations, advertising themselves as "party

members" and "revolutionaries."[252] As a result, although the vast
majority of people[253] in our party and in our ranks are true,
nevertheless, if we are to lead the revolutionary movement to
develop in a better way and be the sooner completed, then we
must conscientiously put in order our internal affairs[254] on both
ideological and organizational levels. We have to put things in
order ideologically before we can tackle the organizational level
and begin an ideological struggle between the proletariat and non-
proletarian classes. An ideological struggle has already begun
among writers and artists in Yan'an, which is very necessary.
People of petty bourgeois origins always persist in expressing
themselves through a variety of ways and means, including litera-
ture and art, propagating their own proposals and urging people
to remake the party and the rest of the world in the image of
the petty bourgeois intelligentsia. Under these conditions our
job is to raise our voices and say, "Comrades," this game of yours
won't work, the proletariat and the popular masses[255] can't accept
your terms; following your course would be in fact following the
big landlords and big bourgeoisie; that way we'd run the risk of
losing our party, our country, and our own heads.[256] Who are
the only people we can rely on? We must rely on the proletariat
and its vanguard[257] to remake the party and the rest of the world
in their image. We hope that the comrades who are writers and
artists recognize the seriousness of this great debate and partici-
pate actively in the struggle directed toward the enemy, friends,
comrades, and ourselves,[258] so that every comrade is strengthened
and our entire ranks are genuinely united and consolidated on both
the ideological and organizational level.

Because of their many ideological problems, many of our
comrades are also largely unable to distinguish correctly between
base areas and nonbase areas,[259] and in consequence make many
mistakes. Many comrades have come from Shanghai garrets, and
the passage from garret to base area[260] involves not just two dif-
ferent localities but two different historical eras. One is a semi-
feudal, semicolonial society ruled by big landlords and the big
bourgeoisie; the other is a revolutionary new democratic society
under the leadership of the proletariat. To arrive in a base
area[260] is to arrive in a period of rule[261] unprecedented in the
several thousand years of Chinese history, one where workers,
peasants, and soldiers, and[262] the popular masses hold power;
the people we encompass, the object of our propaganda, are now
completely different. The eras of the past are gone forever and

will never return. We must therefore join together with the new masses, without the slightest hesitation. If comrades living among the masses are still like the "heroes without a battlefield, remote and uncomprehending" that I spoke about before, then they will find themselves in difficulties not only when they go down to the villages but even right here in Yan'an. Some comrades think, "Why don't I write for readers in the general rear,[263] that's something I know well and it's also a matter of 'national significance.'" This kind of thinking is completely incorrect. The general rear[263] is also changing,[264] and readers there don't need to listen to writers from base areas[265] repeating the same boring old tales; they're hoping that writers in base areas[265] will present them with new characters, a new world. The national significance of a piece of work, therefore, is wholly dependent on its serving the masses in the base areas.[265] Fadeyev's *The Nineteen* only describes a small guerrilla band, with no thought at all of appealing to the taste of old world readers, but its influence has spread throughout the world[266]. China is going forward, not back, and the force that is leading China forward is the revolutionary base areas and not a backward area in retreat; comrades engaged in correcting their work styles must first of all recognize this fundamental question.

Since we must join in the new era of the masses, we must thoroughly resolve the question of the relationship between the individual and the masses. Lu Xun's couplet,

> Stern browed I coolly face the fingers of a
> thousand men,
> Head bowed I'm glad to be an ox for little
> children,

should become our motto. The "thousand men" are the enemy, we will never submit to any enemy no matter how ferocious. The "children" are the proletariat and the popular masses. All Communist Party members, all revolutionaries, and all revolutionary workers in literature and art should follow Lu Xun's example and be an ox for the proletariat and the popular masses, wearing themselves out in their service with no release until death. The intelligentsia must join in with the masses and serve them; this process[267] can and definitely will involve a great many trials and hardships, but as long as we are resolute, these demands are within our grasp.

In my talk today I have only covered a few fundamental questions on the direction to take in our literary and art movement, and there are still many concrete questions that require further study. I believe that our comrades are resolved to take this direction. I believe that in the process of correcting their work styles, in the long period ahead of study and work, our comrades can definitely transform themselves and their work, creating many fine works that will be enthusiastically welcomed by workers, peasants, and soldiers,[268] and the popular masses, and pushing forward the literary and art movement in the base areas[265] throughout the whole country toward a glorious new stage.

APPENDIX 1:
MAJOR CHANGES FROM THE 1943/1944 TEXT
TO THE 1953/1966 TEXT*

1. correct relationship: relationship

2. national liberation: popular liberation

3. slavish culture: compradore culture

4. Red Army struggles: revolutionary struggles

5. Omit: and each fought as an independent army

6. integrating with the people's movement: completely integrating with the popular masses

7. They are: I believe they are

8. friends: allies in the popular front

9. proletariat: popular masses

10. Omit: Should we "praise" the enemy, Japanese fascists and all other enemies of the people? Certainly not, because they are the very worst kind of reactionaries. They may have some superiority on a technical level, so that we can say, for example, that their guns and artillery are quite good, but good weapons in their hands are reactionary. The task of our armed forces is to capture their weapons and turn them against the enemy to seize victory.

11. cultural army: workers in revolutionary literature and art

* These are the changes that survive translation. An exhaustive list of all changes can be found in *Mō Takutō shū* (see Appendix 2, item 8).

12. <u>Add</u>: over the enemy, Japanese imperialism, and all other enemies of the people

13. <u>Omit</u>: our friends,

14. of various kinds: of various kinds in the united front

15. criticize and oppose: firmly oppose

16. <u>Add</u>: and struggle with their own shortcomings and mistakes

17. <u>Add</u>: excepting only those who cling to their errors

18. Border Area: Shaanxi-Gansu-Ningxia Border Area

19. general rear: Nationalist-controlled areas

20. or: and even less so

21. cadres in the party, the government, and the army: revolutionary cadres

22. Yours is the language of intellectuals, theirs is the language of the popular masses.: That is, you lack an adequate knowledge of the rich, lively language of the popular masses. Because many workers in literature and art have cut themselves off from the masses and lead empty lives, they are naturally unfamiliar with popular speech, so that not only does the language they write in seem rather dull, but in addition they frequently insert strange and unfamiliar expressions which they have just made up and which are quite out of keeping with popular usage.

23. <u>Omit</u>: I have mentioned before that

24. we should start by studying: we should conscientiously study

25. the masses' language: a great deal of the masses' language

26. workers, peasants, and soldiers: workers and peasants

27. workers, peasants, and soldiers: workers, peasants, and soldiers in the revolutionary army

28. <u>Omit</u>: not only spiritually unclean in many respects but even physically

29. big and petty bourgeoisie: the bourgeoisie and petty bourgeois intelligentsia

30. Marxist-Leninist: Marxist

31. general knowledge: knowledge

32. the objective determines the subjective: existence determines consciousness

33. the movement: work

34. indecisiveness: vacillation

35. internally: in regard to the people

36. <u>Insert</u>: in the base areas

37. <u>Insert</u>: and workers and peasants

38. the general rear: Nationalist-controlled areas

39. our problem is . . . one of: our problems are

40. this problem . . . it: these problems . . . them

41. <u>Omit</u>: some further explanation with

42. <u>Insert</u>: This problem was solved long ago by Marxists, especially by Lenin. As far back as 1905 Lenin pointed out emphatically that our literature and art should "serve the millions and tens of millions of working people."

43. <u>Omit</u>: or even spies sent by the enemy or the Special Branch of the Nationalist party masquerading as writers and artists

44. apart from such people, the rest: the vast majority

45. <u>Omit</u>: to be involved in

46. <u>Omit</u>: even

47. slave culture, or slave literature and art: traitorous literature and art

48. Omit: There is also another kind of literature and art, which serves the Special Branch and may be called Special literature and art: it may be "revolutionary" on the surface, but in reality it belongs with the three categories above.

49. Insert: We should take over the rich legacy and excellent traditions in literature and art that have been handed down from past ages in China and foreign countries, but our aim must still be to serve the popular masses.

50. the old forms of the feudal class and the bourgeoisie: the literary and artistic forms of past ages

51. the petty bourgeoisie: the urban petty bourgeoisie

52. war: revolutionary war

53. the petty bourgeoisie: the laboring masses and intelligentsia of the urban petty bourgeoisie

54. Omit: We should also make alliances with anti-Japanese elements in the landlord class and bourgeoisie, but they do not support democracy among the broad popular masses. They have a literature and art of their own, while our literature and art are not for them and are in any case rejected by them.

55. Workers, peasants, and soldiers are again the most important element in these four groups: the petty bourgeoisie are fewer in number, their revolutionary determination is weaker and they have a higher cultural level than workers, peasants, and soldiers. Our literature and art are therefore primarily for workers, peasants, and soldiers, and only secondarily for the petty bourgeoisie. Here, we must not raise the petty bourgeoisie to a primary position and relegate workers, peasants, and soldiers to a secondary position.: To serve these four groups of people we must identify ourselves with the proletariat and not the petty bourgeoisie. Today, writers who cling to individualism and identify themselves with the petty bourgeoisie cannot genuinely serve the revolutionary masses of workers, peasants, and soldiers; their interest is mainly in a small number of petty bourgeois intellectuals.

56. The problem we have now with one group of comrades, or the key to their inability: The key to the present inability of one group of comrades

57. that is: or

58. workers, peasants, and soldiers: the masses of workers, peasants, and soldiers

59. the petty bourgeoisie: the petty bourgeois intelligentsia

60. members of the petty bourgeoisie: the petty bourgeois intelligentsia

61. the intelligentsia: the petty bourgeois intelligentsia

62. the intelligentsia from petty bourgeois backgrounds: them

63. the shortcomings of the petty bourgeoisie: their shortcomings

64. workers, peasants, and soldiers: the masses of workers, peasants, and soldiers

65. workers, peasants, and soldiers: laboring people

66. petty bourgeois: petty bourgeois intelligentsia

67. Omit: popular speech

68. the intelligentsia, the petty bourgeoisie: the petty bourgeois intelligentsia

69. have their arses: stand

70. people: many people

71. arses: standpoint

72. Insert: , the side of the proletariat,

73. Marxism-Leninism: Marxism

74. Add: , that genuinely serves the proletariat.

75. Omit: in some respects

76. that disunity on the front of revolutionary literature and art is caused by lack of a common purpose, and that this common purpose is to serve workers and peasants.: "The prerequisite for a united front is a common purpose. . . . Our inability to form a united front shows our inability to reach agreement on our purpose, and that we are only serving the interests of a small group or even indeed one individual. If our purpose were to serve the masses of workers and peasants, then of course our front would also be united."

77. people: the rulers

78. Marxism-Leninism: Marxism

79. is fully applicable: must actually have some effect

80. which only comes from books: in words

81. If we move this Marxism-Leninism out of books and into the masses so that it becomes a living Marxism-Leninism,: If we change this Marxism in words into a Marxism in real life,

82. Add: one-sidedly and exclusively

83. Add: fact of a

84. Add: moreover

85. Feudal things?: Things that are necessary to and readily accepted by the feudal class?

86. Bourgeois things?: Things that are necessary to and readily accepted by the bourgeoisie?

87. Petty bourgeois things?: Things that are necessary to and readily accepted by the petty bourgeois intelligentsia?

88. what belongs to: things that are necessary to and readily accepted by

89. petty bourgeois: petty bourgeois intelligentsia

90. workers, peasants, and soldiers: the masses of workers, peasants, and soldiers

91. Omit: on the basis of their present cultural level and their budding literature and art

92. heights: "heights"

93. Add: , in the direction of proletarian development

94. Reaching a wider audience and raising standards are both worthy activities, but from what source do they arise?: What finally is the source from which all kinds of literature and art arise?

95. Omit: on whatever level of operation

96. result: product

97. Omit: and processing

98. popular life: a certain social life

99. literature and art: the raw materials of literature and art

100. Add: in this respect,

101. Omit: processed forms of

102. exists: can exist

103. Omit: Well, you can say they are a source, but a secondary and not a primary one

104. books and other works already in existence: works of literature and art from the past

105. processed and fabricated from the literature and art: created from the raw materials of literature and art

106. perceived: found

107. absorb these things: take over all the excellent tradition in literature and art

108. using them as models [from which we may learn what to accept and what to reject] : critically assimilating whatever is beneficial and using them as examples

109. process works of literature and art as conceptualized forms: create works

110. literature and art: raw materials of literature and art

111. as models: as legacies and models

112. they are only models and not substitutes: they are legacies and models, and cannot in any way become substitutes for our own creative work

113. , imitation, or substitution: or imitation

114. dead people: the ancients

115. Omit: of the same basic nature as dogmatism in military, political, philosophical, or economic affairs

116. devoting body and soul: devoting their entire energies to [Literally— with whole body and mind: with whole mind and will]

117. all literature and art in their natural form: all the raw material of literature and art

118. processing or creating: creating

119. Omit: where you integrate raw materials with production, the stage of study with the stage of creation

120. Omit: since without raw materials or semi-processed goods you have nothing to process

121. will: you will

122. Although literature and art in their natural form are the sole source of literature and art in conceptualized form,: Although human social life is the sole source of literature and art,

123. literature and art that have been processed are more organized and concentrated than literature and art in their natural form;: life as reflected in works of literature and art, compared with ordinary actual life, can and ought to be on a higher plane, more intense, more concentrated;

124. Omit: The living Lenin was infinitely more vigorous and interesting than the Lenin of fiction, drama, and film, but the living Lenin did so many things in the course of a single day, and so much of what he did was identical with other people's work; besides, very few people ever saw Lenin, and after his death no one could ever see him again. In these respects, the Lenin of fiction, drama, and film is superior to the living Lenin.

125. fiction, drama, film, and so on: literature and art

126. can: should

127. hunger: hunger, cold

128. Omit: organize and

129. making it typical: making its contradiction and struggle typical

130. processed literature and art: literature and art of this kind

131. Omit: but only literature and art in their natural form,

132. Literature and art for a wider audience and literature and art to raise standards are both processed forms, so what is the difference between them? There is a difference of degree.: What do reaching a wider audience and raising standards mean in regard to literature and art? What kind of relationship exists between these two tasks?

133. Literature and art for a wide audience indicates that the processing has been relatively limited and crude,: Things for a wide audience are relatively simple and plain,

134. literature and art to raise standards indicates that the processing has been relatively extensive and skillful, and hence, relatively difficult for [the broad popular masses at the present time to accept readily].: advanced works are more polished,

and hence difficult to produce, and often more difficult to
circulate readily among the broad masses at the present
time.

135. bitter struggle: bitter and bloody struggle

136. illiterate, ignorant, and uncultured: illiterate and uncultured

137. their most urgent demand, therefore, is for a wide-reaching
educational movement in the form of cultural knowledge and
works of literature and art that they urgently need and can
readily accept,: they urgently demand a wide-reaching educa-
tional movement together with cultural knowledge and works of
literature and art that meet their urgent needs and are easy
to absorb,

138. The first step for them is not a question of: The first need
for them is still not

139. The most serious and central task in regard to the people,
therefore, is initially the work of reaching a wider audience
rather than raising standards.: Under present conditions,
therefore, the task of reaching a wider audience is the more
pressing.

140. If the people providing the material for wider audiences aren't
on a higher level than their audience, then what is the point
of trying to reach them at all?: Not only is it possible for some
excellent works even now to reach a wider audience, but also
the cultural level of the broad masses is steadily rising.

141. Omit: invariably

142. the people who prepare the material and the audience they
are reaching? [the people who reach and the people who are
reached?]: the educators and the educated?

143. Wouldn't it be pointless to reach: What would be the point of
reaching

144. the experience: good experience

145. Omit: of reaching a wider audience and raising standards,

146. Omit: provided that their experience is good

147. But the material used in raising standards for guidance never involves crude imitation, since this would only destroy its usefulness.: Precisely for this reason, the work of reaching wider audiences that we are speaking of not only does not hinder raising standards, but gives a basis for the work of raising standards, which is now limited in scope, and also prepares the necessary conditions for us to raise standards in the future on a much broader scale.

148. who have generally already completed the kind of education currently offered to the masses;: who have generally received more education than the masses.

149. Omit: their ability to absorb things is higher than the masses, so that material intended for wider audiences among the masses at their present level, such as "The Little Cowherd," cannot satisfy them.

150. Omit: But for the time being this kind of need is confined to cadres and not generally felt among the masses; it should be our goal to meet this need, but it should not become the total or the central goal today.

151. At the same time we should understand that in serving cadres: In serving cadres

152. processing: creative labor

153. advanced mass literature and art: advanced literature and art

154. lower-grade mass literature and art: elementary literature and art

155. serve: mostly serve

156. Omit: (which isn't to say literature and art with low standards of taste)

157. comrades: people

158. <u>Omit</u>: Gorky was active in editing factory histories, guiding village correspondents, and guiding young people in their teens, while Lu Xun also spent a great deal of time on general correspondence with students.

159. <u>Omit</u>: on the lowest level

160. replenishing, enriching, and nourishing: replenishing and enriching

161. guild utilitarians: narrow utilitarians

162. himself and his friends or a small group of people: a few people

163. a large number of people benefit greatly from it: it is in the real interests of the popular masses

164. which aristocrats enjoy: which, for the time being, a minority enjoys

165. all the other questions: the other questions

166. <u>Omit</u>: position, attitude, audience, material,

167. <u>Omit</u>: versus opposition

168. utilitarianism versus super-utilitarianism and narrow utilitarianism versus long-range utilitarianism.: and so on.

169. we: all of us

170. serve this goal.: act in accordance with this goal.

171. class and party: class

172. <u>Omit</u>: In a society composed of classes and parties, art obeys both class and party, and it must naturally obey the political demands of its class and party, and the revolutionary task of a given revolutionary age; any deviation is a deviation from the masses' basic need.

173. "a screw in the whole machine": "a cog and screw" in the whole revolutionary machine

174. Add: and is subordinate to the revolutionary task set by the party in a given revolutionary period

175. excessive emphasis: excessive emphasis to a mistaken degree

176. screw: cog or screw

177. other parts: other more important parts

178. the revolution: the revolutionary movement

179. Ideological warfare and literary and artistic warfare, especially if these wars are revolutionary, are necessarily subservient to political warfare,: Revolutionary ideological struggles and literary and artistic struggles are necessarily subservient to the political struggle,

180. propertied: rotten bourgeois

181. Omit: , a difference that also exists between their respective politics. Add: . It is precisely for this reason that there can be complete accord between the political character of our literature and art and their truthfulness.

182. narrow or conventional: conventional

183. bourgeois and landlord writers and artists: all bourgeois and landlord writers who support resistance to Japan

184. writers and artists: anti-Japanese writers and artists

185. artistic style: artistic methods and style

186. proletarian realism: socialist realism

187. Omit: probably

188. what Lenin called a hamstrung policy.: mistaken policy.

189. workers, peasants, and soldiers: laboring people

190. masses of workers, peasants, and soldiers.: laboring people.

191. deficient: quite deficient

192. discuss: concentrate on discussing

193. miscellaneous: specific

194. good or better,: good,

195. bad or worse.: bad.

196. his works: chiefly his works

197. works: the existence of works

198. Add: and repudiate

199. Omit: (even if it is on a very high level of art)

200. a methodology of artistic creation: methods of artistic creation and criticism

201. in every class society and in every class within that society,: in every class in every class society,

202. artistic quality [degree].: artistic achievement.

203. reject the reactionary political qualities of bourgeois works of literature and art and accept their artistic qualities only with discrimination.: distinguish between works of literature and art from past ages by first examining their attitude towards the people and whether they have any progressive significance in history, and determine their own attitude accordingly.

204. Omit: for example, fascist literature and art

205. highest: most perfect

206. with a harmful content: with mistaken political views

207. which is only concerned with content and not with form;: which only has correct political views but no artistic power;

208. among many of our comrades.: in the thinking of many of our comrades.

209. <u>Add</u>: , not in the abstract

210. has: only has

211. <u>Omit</u>: in the abstract,

212. <u>Add</u>: and the popular masses

213. the bourgeoisie and the petty bourgeoisie: the landlord class and the bourgeoisie

214. <u>Add</u>: . The human nature encouraged by a few members of the petty bourgeois intelligentsia is divorced from or opposed to the popular masses, and what they call human nature is in fact nothing but bourgeois individualism

215. <u>Omit</u>: so-called

216. <u>Add</u>: so-called

217. society has sentenced both to a common fate and integrated our two separate lives into one.: society has made them feel that they share a common fate with the proletariat.

218. split: divided

219. The ruling classes, Confucius, and even Tolstoy all upheld it,: All ruling classes in the past and many so-called sages and wise men have been fond of upholding it,

220. Classes cause splits within society,: Classes divide society into many opposing groups,

221. <u>Omit</u>: and unity restored

222. <u>Omit</u>: fascists,

223. <u>Add</u>: and describes negative characters

224. shortcomings: descriptions

225. the science of history and historical materialism: scientific knowledge of history

226. <u>Add</u>: and the evil influence they have on people,

227. but these are chiefly a result of the rule exercised over them by aggressors, exploiters, and oppressors, so that our revolutionary writers and artists should expose them as evils for which aggressors, exploiters, and oppressors are responsible;: and these shortcomings should be overcome by criticism and self-criticism within the people's own ranks, and one of the most important tasks of literature and art is to carry out such criticism and self-criticism;

228. only: fundamentally

229. <u>Omit</u>: If we take the essay and the Lu Xun style just to mean satire, then this view is only correct when it applies to enemies of the people.

230. <u>Add</u>: and everything that harms the people

231. <u>Omit</u>: and Special Branch

232. should not take: should not simply take

233. that the popular masses can't understand.: that isn't easy for the popular masses to understand.

234. with the ruthless methods required against the enemy,: in the same way as we treat the enemy,

235. <u>Add</u>: No, satire is always needed.

236. There are: There are, however,

237. friends,: allies,

238. each of these three attitudes: each attitude

239. get rid of: oppose

240. definitely: necessarily

241. world and of history?: history, mankind, and the world?

242. the people: the proletariat

243. <u>Omit</u>: his sweetheart as well, plus

244. whether: how many of

245. or what are known as: , what is known in creative work as

246. "Studying: "To uphold the study of

247. Marxism-Leninism: Marxism

248. <u>Omit</u>: only

249. Marxism-Leninism: "Marxism"

250. <u>Omit</u>: three

251. foreign dogmatism: dogmatism

252. <u>Omit</u>: Of course, some people are even worse: on the organizational level, they join the Japanese party, Wang Jingwei's party, or the Special Branch of the big bourgeoisie and big landlords party, but afterwards they also bore their way into the Communist party or Communist-led organizations, advertising themselves as "party members" and "revolutionaries."

253. the vast majority: the majority

254. put in order our internal affairs: put things in order

255. <u>Omit</u>: and the popular masses

256. , our country, and our own heads.: and our country.

257. the proletariat and its vanguard: the vanguard of the proletariat

258. <u>Omit</u>: directed towards the enemy, friends, comrades, and ourselves

259. base areas and nonbase areas,: revolutionary base areas and Nationalist-controlled areas,

260. base area: revolutionary base area

261. period of rule: period

262. Omit: workers, peasants, and soldiers, and

263. general rear: 'general rear'

264. is also changing: will also change

265. base areas: revolutionary base areas

266. Add: ; at least in China, as you know, it had a very great influence

267. join in with the masses and serve them; this process: join in with the masses and serve them, they must go through a process where each side gets to know the other. This process

268. Omit: workers, peasants, and soldiers, and

APPENDIX 2:
SOME MAJOR EDITIONS OF THE "TALKS"

1. "Zai Yan'an wenyi zuotanhuishangde jianghua" [Talks at the Yan'an conference on literature and art], *Jiefang ribao,* 19 October 1943, p. 1.* This is the basic text for all editions up to February 1953. Unless otherwise noted, the title is the same in all subsequent editions.

2. *Zai wenyi zuotanhuide jianghua—yinyan yu jielun* [Talks at the Yan'an conference on literature and art—introduction and conclusion] (Yan'an: Jiefang she, October 1943). Cover title: "Wenyi wenti" [Problems of literature and art]. The first fourteen pages of text are numbered 317-30; the remaining twenty-two pages are unnumbered. This edition is not listed in the *Wenwu* bibliography (see below).

3. Eighty-four single volume editions of the "Talks" under various titles published between October 1943 and March 1953 are listed with brief descriptions in *Wenwu,* no. 5 (May 1972), pp. 17 and 29; for more details, see the accompanying article by Qi Si from Peking Library, "'Zai Yan'an wenyi zuotanhuishangde jianghua' banben luetan" [A brief talk on the editions of "Talks at the Yan'an Conference on Literature and Art"], pp. 10-16.

4. In *Zhengfeng wenxian* [Rectification documents] (Yan'an: Xinhua shudian, 1945)*; rev. ed., 1946; rev. ed., 1949; rev. ed., 1950. I have not tried to determine the difference between these "editions." Most of the documents in this collection, which seems to have circulated widely in China, have been translated in Boyd Compton's *Mao's China: Party Reform Documents, 1942-1944* (Seattle, 1950). Compton does not indicate which text he used, and there are undoubtedly more "editions" than the ones

* Asterisks are used to indicate works that I have personally seen and checked.

listed above. Compton does not translate the "Talks" in his selection.

5. In pre-Liberation *Selected Works*. All editions in this section and in section 6 below have the title *Mao Zedong xuanji* [Selected works of Mao Zedong], familiarly known as *Maoxuan*.

 a. *Maoxuan*, 5 vols. (Shaanxi-Chahaer-Hebei Xinhua shudian, May 1944).* For reprint, see item 8 below.

 b. *Maoxuan*, 6 vols. (Shaanxi-Chahaer-Hebei Central Bureau of the CCP, 1947)*; reprinted in 2 vols. (Washington, D.C.: Center for Chinese Research Materials, 1970).

6. In post-Liberation *Selected Works*. In all of these editions, the "Talks" are in vol. 3, and the texts are identical.

 a. *Maoxuan*, 4 vols. (Peking, 1951-60).

 b. *Maoxuan*, 4 vols., 2d ed. (reset) (Peking, 1952-60).*

 c. *Maoxuan*, 4 vols., rev. ed. (simplified characters and horizontal layout) (Peking, 1966).*

7. With other writings on literature and art:

 a. *Mao Zedong lun wenxue yu yishu* [Mao Zedong on literature and art] (Peking: Renmin wenxue chubanshe, 1958).* The "Talks" were reprinted from the edition listed in item 6b above, vol. 3.

 b. *Mao Zedong lun wenyi* [Mao Zedong on literature and art] (Peking: Renmin wenxue chubanshe, 1958).* The contents and pagination are identical with the edition in item 7a above, but the introductory material is different.

 c. *Mao Zedong lun wenxue he yishu* (Peking: Renmin wenxue chubanshe, 1966).* A revised edition of item 7a above with additional material; the text of the "Talks" is identical to that in item 7a.

 d. *Mao Zedong lun wenyi* (Peking: Renmin wenxue chubanshe, 1966).* The contents and pagination are identical with the edition in item 7c above, but the introductory material is different.

8. Variorum editions:

Mō Takutō shū [Collected writings of Mao Zedong], 10 vols. (Tokyo: Hokubō sha, 1970-72).* Reprints of early versions of Mao's writings; the "Talks" are reprinted from the edition listed in item 5a above.

The present translation is based on item 2 above. Apart from very minor differences in punctuation and wording, this edition is the same as the 1944 *Maoxuan* version as reprinted in *Mō Takutō shū*. I have found the three *Maoxuan* texts listed in item 6 to be identical except for pagination; they are also identical to items 7a and 7b. My basic text for comparison with the 1943/1944 editions has been the edition listed in item 6b, vol. 3.

APPENDIX 3:
TRANSLATIONS OF THE "TALKS"

I. Translations of pre-1953 versions.

 A. Incomplete translations:

 1. Stuart R. Schram, in his *The Political Thought of Mao Tse-tung*, rev. ed. (New York: Praeger, 1969). Excellent idiomatic and accurate translation based on the *Jiefang ribao* text, with emphases and notes showing important differences from the 1953 text.

 2. Adele Rickett, in *A Documentary History of Chinese Communism*, ed. Conrad Brandt, Benjamin I. Schwartz, and John K. Fairbank (Cambridge, Mass.: Harvard University Press, 1952). Based on the March 1946 edition of *Zhengfeng wenxian*; an accurate and representative selection of the major passages.

 B. Complete translations:

 1. Ch'en Chia-k'ang and Betty Graham, trans., *On Literature and Art* (n.p.: The Chefoo News, n.d. [1950?]). This edition does not indicate the source of the translation.

 2. *Problems of Art and Literature* (New York: International Publishers, 1950). No translator is given and the source is not indicated. Reprinted in July 1950 by the People's Publishing House, Bombay; new impressions, 1951 and 1952.

Both of these editions are out of print and therefore not easily obtainable; more importantly, both contain a large number of minor errors and false emphases, which, though not affecting the general message of the "Talks," makes them unsuitable for close study. For example, both versions emphasize unduly the accomplishments of prewar literature

and art; the Chefoo version occasionally translates "cadres" as "sympathizers," while the New York version at one point identifies cadres as workers, soldiers, and peasants; the Chefoo version raises the social status of prewar readers to "professionals" and "employers" (the former is simply not a very good translation of *zhiyuan*, and the latter may be a misprint for "employees" *dianyuan*); and the New York version very much exaggerates and ridicules the snobbishness of students who are unable to carry their own belongings.

In the present translation I have tried to stay as close as possible to the text, within the limits of acceptable English, and have tried to reproduce the tone and emphasis of the original, which on the whole is easy and conversational. Many expressions appearing in Mao's works now have standard translations that have achieved the status of technical terms, but since the present translation is not primarily directed toward political scientists, I have preferred to choose English expressions that more closely approximate the original words and to use jargon only where jargon appears in the text. I have also tried to keep in mind the fact that Mao's works are frequently quoted without context, and for this and other reasons I have kept strictly to the original sentence lengths while disregarding other punctuation not corresponding to American usage. The translation is intended chiefly for people with no knowledge of Chinese at all, and the reader with knowledge of Chinese will soon discover that much of the charm of the original has been lost in the interest of clarity.

II. Translations of post-1953 versions.

 A. Translations from *Selected Works*:

 1. *Mao Tse-tung: Selected Works*, 5 vols. (New York: International Publishers, vols. 1-4, 1954-56; vol. 5, n.d.).* According to the publisher's note in vol. 1, this translation is based on the Peking edition of *Maoxuan* of 1951-60. The "Talks" are in vol. 4. Vol. 5 appears to be a reprint of the Peking translation of 1961; see item 3 below.

 2. *Selected Works of Mao Tse-tung*, 5 vols. (London: Lawrence and Wishart, vols. 1-4, 1954-56).* I have not seen a copy of vol. 5 to date. This translation

claims to be based on the Peking edition of *Maoxuan* of 1952-60. The "Talks" are in vol. 4 and are identical in all respects including pagination to the New York edition listed in item 1 of this section.

3. *Selected Works of Mao Tse-tung,* 4 vols. (Peking: Foreign Languages Press, vols. 1-3, 1965; vol. 4, 1961).* The translations in vols. 1-3 are said to be based on the 1960 2d ed. (sic) of *Maoxuan* and those of vol. 4 on the 1960 first edition. The "Talks" are in vol. 3 and differ in many respects from the translation of items 1 and 2 listed above in this section. Reprints of this translation have appeared at least into 1975 and maybe later, so that there appear not to have been retranslations from the 1966 *Maoxuan.* In general, this translation is to be preferred as more accurate and also as the "official" translation.

B. Translations in other collections of Mao's writings:

1. *Mao Tse-tung on Art and Literature* (Peking: Foreign Languages Press, 1960); based on the 1958 *Maoxuan* (sic); a rev. ed. also appeared in 1960.*

2. *Mao Tse-tung on Literature and Art* (Peking: Foreign Languages Press, 1967).* This is the 2d rev. ed. of item 1 of this section, with one additional article. There are substantial differences between the translation of the "Talks" in item 1 of this section and in this edition.

3. *Talks at the Yenan Forum on Literature and Art* (Peking: Foreign Languages Press, 1956)*; based on the 1953 *Maoxuan*; rev. ed., 1960*; 2d rev. ed., 1962*; 3d rev. ed., 1965.

4. *Talks at the Yenan Forum on Literature and Art* (Peking: Foreign Languages Press, 1967).* This is a new edition of item 3 of this section with additional material.

The translations that appeared before 1965 (items B1 and B3 of this section) are apparently to some extent based on the New York/London translation from the *Selected Works.* The translations from after 1965 are all based on the Peking translation of the *Selected Works*; apart from one very minor

difference in item B4 of this section, they are identical in
text but differ slightly in the number and content of foot-
notes. This is by no means an exhaustive list of transla-
tions in English coming from China.

III. Translations of other writings by Mao on literature and art,
and of his poetry:

Mao's official comments on literature and art are contained
in the four short anthologies listed above in section II, items
B1-4, which cover the period 1937-57, and in *Five Documents
on Literature and Art* (Peking, 1967), which covers the period
1944-64. For partial translations of the original texts of some
of these documents, see Schram's *The Political Thought of Mao
Tse-tung*. For some of his unofficial remarks, which became
available after the Cultural Revolution from various unofficial
sources, see Stuart R. Schram's *Mao Tse-tung Unrehearsed*
(Harmondsworth, 1974), esp. pp. 79, 123, 152-53, and 215.
Mao's contempt for the kind of poetry being written in the fifties
and sixties was not openly acknowledged during his lifetime.
Now, however, a private letter written to Chen Yi expressing
these opinions has been publicly released, and these opinions
have been adopted as policy directives. For a translation of the
letter, see *Peking Review* 21, no. 2 (13 January 1978): 6-7;
ziyoushi ("free verse") is mistranslated as "unorthodox verse."

The most readily available translations of Mao's poetry are
the 1976 Peking edition of his work *Poems*, and *The Poetry of
Mao Tse-tung*, with translation, introduction, and notes by
Hua-ling Nieh Engle and Paul Engle (London, 1972). The chief
value of the Engles' book is their translation of essays by Guo
Moruo on several individual poems; otherwise, their annotations,
while helpful for background, are not very profound. The
Peking edition has very few notes, but most of the poems do
not require notes to be comprehensible. As to the translations,
the Peking version has a slight edge, in my opinion; the formal
denseness of the original is better conveyed than in the rather
flat style of the Engles. The Peking version has the added ad-
vantage of being official and will be familiar to readers of other
English-language Chinese publications. There is also a bilingual
edition of the Peking version. For a complete list of translations
and articles on the poems, see Donald A. Gibbs and Yun-chen
Li, *A Bibliography of Studies and Translations of Modern Chinese*

Literature, 1918-1942 (Cambridge, Mass., 1975). Fine translations by Cyril Birch of a selection of Mao's poems have just been published in *Literature of the People's Republic of China,* ed. Kai-yu Hsu (Bloomington, Ind., 1980), pp. 373-76 and 843-44.

MICHIGAN PAPERS IN CHINESE STUDIES

No. 2. *The Cultural Revolution: 1967 in Review*, four essays by Michel Oksenberg, Carl Riskin, Robert Scalapino, and Ezra Vogel.

No. 3. *Two Studies in Chinese Literature*, by Li Chi and Dale Johnson.

No. 4. *Early Communist China: Two Studies*, by Ronald Suleski and Daniel Bays.

No. 5. *The Chinese Economy, ca. 1870–1911*, by Albert Feuerwerker.

No. 8. *Two Twelfth Century Texts on Chinese Painting*, by Robert J. Maeda.

No. 9. *The Economy of Communist China, 1949–1969*, by Chu-yuan Cheng.

No. 10. *Educated Youth and the Cultural Revolution in China*, by Martin Singer.

No. 11. *Premodern China: A Bibliographical Introduction*, by Chun-shu Chang.

No. 12. *Two Studies on Ming History*, by Charles O. Hucker.

No. 13. *Nineteenth Century China: Five Imperialist Perspectives*, selected by Dilip Basu, edited by Rhoads Murphey.

No. 14. *Modern China, 1840–1972: An Introduction to Sources and Research Aids*, by Andrew J. Nathan.

No. 15. *Women in China: Studies in Social Change and Feminism*, edited by Marilyn B. Young.

No. 17. *China's Allocation of Fixed Capital Investment, 1952–1957*, by Chu-yuan Cheng.

No. 18. *Health, Conflict, and the Chinese Political System*, by David M. Lampton.

No. 19. *Chinese and Japanese Music-Dramas*, edited by J. I. Crump and William P. Malm.

No. 21. *Rebellion in Nineteenth-Century China*, by Albert Feuerwerker.

No. 22. *Between Two Plenums: China's Intraleadership Conflict, 1959–1962*, by Ellis Joffe.

MICHIGAN ABSTRACTS OF CHINESE AND JAPANESE WORKS ON CHINESE HISTORY

No. 1. *The Ming Tribute Grain System*, by Hoshi Ayao, translated by Mark Elvin.

No. 2. *Commerce and Society in Sung China*, by Shiba Yoshinobu, translated by Mark Elvin.

No. 3. *Transport in Transition: The Evolution of Traditional Shipping in China*, translations by Andrew Watson.

No. 4. *Japanese Perspectives on China's Early Modernization: A Bibliographical Survey*, by K. H. Kim.

No. 5. *The Silk Industry in Ch'ing China*, by Shih Min-hsiung, translated by E-tu Zen Sun.

No. 6. *The Pawnshop in China*, by T. S. Whelan.

NONSERIES PUBLICATION

Index to the "Chan-kuo Ts'e," by Sharon Fidler and J. I. Crump. A companion volume to the *Chan-kuo Ts'e*, translated by J. I. Crump (Oxford: Clarendon Press, 1970).

Michigan Papers and Abstracts available from:

Center for Chinese Studies
The University of Michigan
104 Lane Hall (Publications)
Ann Arbor, MI 48109 USA

Prepaid Orders Only
Write for complete price listing